IMAGES
of America

SCRANTON

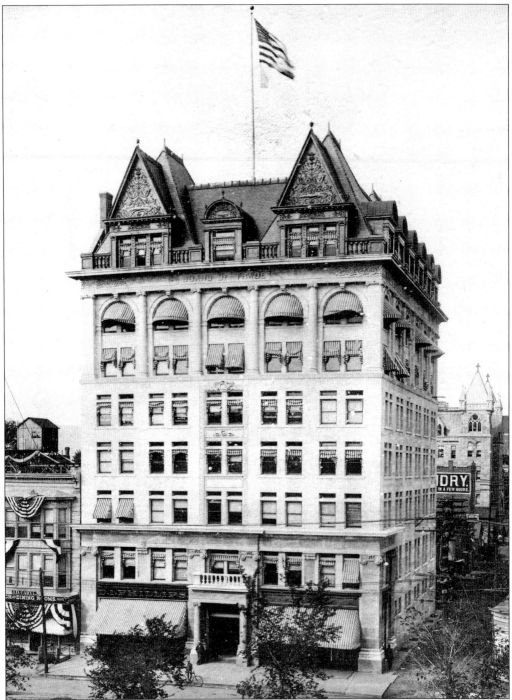

BOARD OF TRADE BUILDING. Begun in 1867, the Wholesale Merchants' Association expanded its function and renamed itself the Board of Trade in 1871. First located over Fuller and Company at 404 Lackawanna Avenue, it moved to Scranton's first skyscraper, pictured here, in 1896. Developers of the Linden Street building rented space to the Board of Trade for a monthly fee of $36 in exchange for use of the organization's prestigious name.

IMAGES of America
SCRANTON

Cheryl A. Kashuba, Darlene Miller-Lanning, and Alan Sweeney

Copyright © 2005 by Cheryl A. Kashuba, Darlene Miller-Lanning, and Alan Sweeney
ISBN 0-7385-3859-0

Published by Arcadia Publishing
Charleston SC, Chicago IL, Portsmouth NH, San Francisco CA

Printed in Great Britain

Library of Congress Catalog Card Number: 2005925676

For all general information contact Arcadia Publishing at:
Telephone 843-853-2070
Fax 843-853-0044
E-mail sales@arcadiapublishing.com
For customer service and orders:
Toll-Free 1-888-313-2665

Visit us on the Internet at http://www.arcadiapublishing.com

All images, unless otherwise noted, appear courtesy of the Lackawanna Historical Society.

On the cover: GEORGE AND MARY CATLIN IN MOTOR CAR. Born in Shoreham, Vermont, George Catlin (1845–1935) began his professional career in 1867 with the New York City law firm of Pope, Thompson, and Catlin. That same year, he married Mary Woodrow Archbald, the daughter of James Archbald of Scranton. In 1870, the Catlins came to live with the Archbalds in their home on Ridge Row. The Catlins are shown here in a motor car outside the Archbald residence.

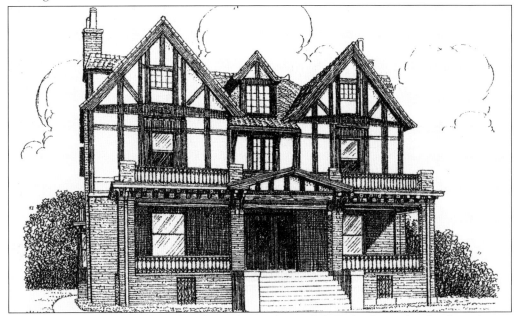

CATLIN HOUSE. Designed by Edward Langley in the English Tudor Revival style, this 16-room mansion was built in 1912 for Scranton lawyer and banker George Catlin and his second wife, Helen Walsh Catlin. Located at 232 Monroe Avenue, near the site of the old Archbald residence, the building is now home to the Lackawanna Historical Society.

CONTENTS

Introduction		7
1.	Early Settlement	11
2.	Industrial Development	33
3.	Urban Growth	57
4.	Business Ventures	79
5.	Community Life	105
Acknowledgments and Bibliography		128

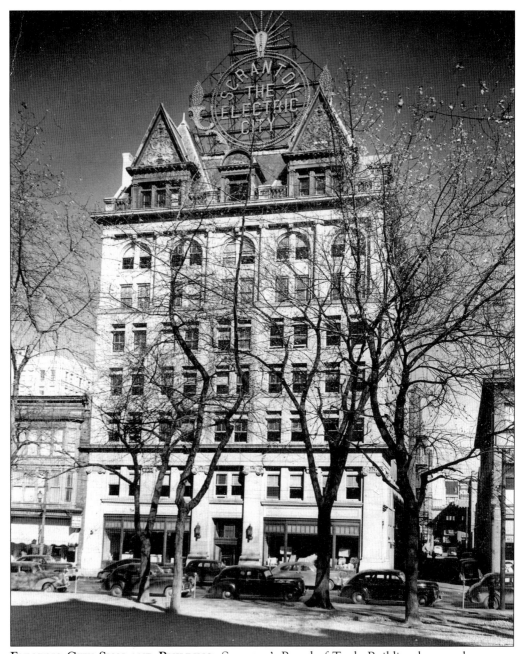

ELECTRIC CITY SIGN AND BUILDING. Scranton's Board of Trade Building became known as the Electric Building in 1923, when it was acquired by the Scranton Electric Company. The building's famous illuminated sign was added soon after. Over the years, its message changed several times, but was restored and relit in 2004 to again proclaim Scranton the "Electric City."

INTRODUCTION

History is an integral part of life in Scranton, Pennsylvania. Every day, local residents, as well as visitors from around the country, immerse themselves in the city's 200 year history of ethnic diversity and industrial growth, preserved and interpreted at Steamtown National Historic Site; Pennsylvania's Anthracite Heritage Museum and Scranton Iron Furnaces; and Lackawanna County's Coal Mine Tour and Electric City Trolley Museum. Beyond the bounds of these official keepers of history, the urban fabric of Scranton itself remembers struggle and triumph, and the cityscape is alive with its own past. The Lackawanna Historical Society, a keeper of a different kind, complements an awareness of Scranton and cultivates an appreciation of the city, both old and new.

In a place where the past is still a tangible presence, the Lackawanna Historical Society has a long and venerable history of its own. Founded as the Lackawanna Institute of History and Science, just eight years after the 1878 formation of Lackawanna County, the organization met in rooms at the Lackawanna County Courthouse, the Albright Memorial Library, the Green Ridge Library, and the Everhart Museum. In 1921, Fletcher Weyburn became the first full-time director of the newly-renamed Lackawanna Historical Society, which, in 1942, moved its offices and collections to the Catlin House. George Catlin, Scranton banker and lawyer, had willed his residence to the society following the death of his widow.

Today, the Lackawanna Historical Society at the Catlin House is a welcoming place, blessed with knowledgeable and enthusiastic board members, staff, and volunteers. Patrons tour period rooms and museum exhibits, and study local histories and photograph collections. This impressive institute plans special events including a Christmas open house, monthly talks, innovative theatrical programs, and tours of local homes, places of worships, business districts, and cemeteries.

No less impressive than the organization responsible for its care and development is the collection itself. Over the past century, this remarkable cache of documents and artifacts has come to include some 6,000 photographs, 4,000 local history publications, and 1,300 maps, newspapers and city directories, as well as genealogies and obituaries, antique furnishings, art, tools, and fashions. Dating from the 18th through the 21st centuries, these images, texts, and objects stand as a record of Scranton's early settlement, industrial development, urban growth, business ventures and community life. To experience the collections of the Lackawanna Historical Society is to experience the history of Scranton. The images and information found in this volume are taken from this collection.

A valued source within the collection is Hollister's *History of the Lackawanna Valley*, first

published in 1857. As the volume notes, colonial settlement—and conflict—began in the Lackawanna Valley during the 18th century. Lands in northeastern Pennsylvania were granted by the British crown to both William Penn, who recognized the territory as Pennsylvania, and to Connecticut, which identified the region along the Lackawanna and Susquehanna Rivers as Westmoreland. By the 1760s, settlers from southern Pennsylvania and eastern Connecticut encountered each other in this previously-remote region, also occupied by Delawares and Iroquois. Between 1769 and 1775, land disputes escalated in a series of ongoing confrontations known as the Yankee-Pennamite Wars. Hostilities were suspended during the American Revolution, but peace did not prevail; in 1778, British and Iroquois forces attacked the region, resulting in the Wyoming Massacre.

Prominently involved in these events were the Tripp and Slocum families, who came to the region as members of the Susquehanna Company. Born in Rhode Island, Isaac Tripp settled in Providence, a community that would one day become part of Scranton. Grandsons Ebenezer and Benjamin Slocum later operated a gristmill, sawmill, and iron forge along the Roaring Brook tributary of the Lackawanna River, in an area known as Dark Hollow or Slocum Hollow. Iron was forged in Slocum Hollow as early as 1797. By the 1820s, the region's ready supplies of water, anthracite, and iron ore attracted the attention of New Jersey ironmaster William Henry. Backed by his relatives George and Selden Scranton, he built an iron furnace, and Slocum Hollow became a thing of the past.

The fledgling furnaces, known as Scrantons and Grant, struggled to produce pig iron and nails, neither of which proved profitable. In 1847, the company secured a contract to manufacture iron "T" rails for the New York and Erie Railroad. At the time, "T" rails used in the United States were primarily obtained through British suppliers, often after a long waiting period. In order to complete its line more quickly, the New York and Erie Railroad placed an order with the Scranton firm. Additional investments were secured, and the furnaces were reconfigured to produce the rails. Powered by this success, the enterprise grew, and over the next several decades was variously known as Scrantons and Platt, the Lackawanna Iron and Coal Company, the Scranton Steel Company, and the Lackawanna Iron and Steel Company.

Photographs and letters found in the Lackawanna Historical Society's collections document the inextricable ties that existed between the Scranton family and its associates, the industries they owned, and the city they inspired. A literal illustration of the ways in which the aspirations and needs of these individuals and organizations intersected is the Lackawanna Historical Society's monumental *Map of Scranton*, prepared by Joel Amsden in 1857. Hired by George Scranton to serve as a civil engineer, Amsden was called upon to design Scranton's city plan, industrialists' homes, numerous churches, and finally, a school. Amsden's *Map of Scranton* shows city streets, lists local businesses, and depicts private residences, public structures, and heavy industries.

Scranton's growing iron and steel industry was closely tied to the development of railroading and mining in the area. Fueled by anthracite, the furnaces' major product was "T" rails. Railroads, also fueled by anthracite, bought "T" rails, and both furnaces and mines needed the railroads to transport raw materials and finished goods. A strong business relationship benefited all three industries.

A Delaware, Lackawanna and Western Railroad advertisement provides a sense of Scranton's connection to the rest of the country. Moving passengers and goods, the railroads were essential to the development of the region and the growing industrial nation. Early railroads operating in Scranton included the Leggett's Gap Railroad and Delaware and Cobb Railroad, which merged to form the Delaware, Lackawanna and Western Railroad. Other major railroading interests included the Delaware and Hudson Canal Company and Delaware and Hudson Gravity Railroad, which grew to become the Delaware and Hudson Railroad; the Central Railroad of New Jersey; the Erie and Wyoming Valley Railroad; and also the Ontario and Western Railroad.

Mining also figured into this complex corporate picture. Anthracite, or "hard" coal, abundant in the Wyoming and Lackawanna Valleys, burns hotter and cleaner than or bituminous, or "soft"

coal, found in the western regions of the state. During the late 19th and early 20th centuries, it was the fuel of choice for iron and railroad industries, and became commonly used as a heating fuel. Numerous small coal companies began operating in Scranton by the 1850s. Investors in the large iron and railroading industries developed sister enterprises like the Delaware, Lackawanna and Western Coal Company and the Delaware and Hudson Coal Company. The dangers and injustices of the mining industry also brought Scranton to the forefront of national attention during the Anthracite Strike of 1902. The Anthracite Coal Strike Commission, appointed by Pres. Theodore Roosevelt to hear the concerns of labor and industry, met at the Lackawanna County Courthouse. This event, which marked the first federal intervention in labor disputes, is commemorated by the John Mitchell Monument, located on Courthouse Square. The monument features a bronze figure of John Mitchell, president of the United Mine Workers of America, as well as two reliefs depicting miners and their families.

From the foundation of Scranton's three major industries grew a new layer of urban life. When Lackawanna County was established in 1878, Scranton responded with its typical vision and energy. Civic leaders erected the stately Lackawanna County Courthouse on a former swamp known as the Lily Pond. A pair of before and after photographs record the construction of this important building. Another major structure, the new city hall, was erected at the corner of North Washington Avenue and Mulberry Street. Both are constructed of native West Mountain stone, linking the city to the very landscape upon which it sits.

The growth of the city was supported by both civic agencies and private citizens. With the expansion of county and municipal offices, fire, police, and postal services also grew and modernized. New, progressive schools were built to accommodate the needs of the increasing population. Photographs of the Central High School Drama Club and the W. T. Smith Manual Training School classes show the breadth of curriculum offered at these educational facilities. To further encourage public education, John J. Albright endowed a public library "for the elevation of the people of all classes." Nineteenth century photographs of the library's interior show patrons borrowing books at the circulation desk.

With nearly 80,000 residents by the beginning of the 20th century, the "Electric City," nicknamed for its streetcar system, was bustling and diverse. A 1905 postcard of a busy Washington Avenue street scene shows the city in transition. Among the newly-constructed buildings, both the old horse-drawn and the new electric trolley cars are visible. A well-dressed businessman strides purposefully down a sidewalk, passing thriving businesses, banks, and the courthouse with its public park. The Board of Trade Building is visible in the distance.

Depictions of the Board of Trade Building demonstrate the growth and transformation of Scranton's business interests. Beginning in 1867, the agency took up residence in Scranton's first skyscraper in 1896. As seen in the introductory photograph to this volume, the building first featured striped canvas awnings and an American flag. Other photographs in the book record the changing messages later found on the building's illuminated rooftop sign: "Scranton: the Electric City and Watch Scranton Grow." Finally, a postcard of the Scranton Chamber of Commerce testifies to the ongoing importance of this organization to a changing community.

Business ventures in Scranton expanded beyond the furnaces, railroads, and mines. These three big industries made possible related enterprises such as the American Locomotive Company and the Dickson Manufacturing Company, producers of steam engines and heavy industrial machinery. Public utilities were developed in the form of the Scranton Gas and Water Company and the Scranton Electric Company, in which the Scranton family was once again deeply involved. As the population of Scranton grew, textile industries such as the Scranton Lace Company and Sauquoit Silk Mills were attracted by energy sources, raw materials, and a large labor pool of young women, in the form of miners' and ironworkers' daughters and wives. Machinery advertisements and raw silk samples survive as tangible links to these industries.

Enterprising financiers invested in modern banks and multi-storied commercial properties such as the Mears Building and the Scranton Life Building. Still, this corporate environment allowed plenty of space for smaller, family-run businesses, from major department stores to

neighborhood groceries. The photograph depicting the Lackawanna Avenue Wholesale Block documents the busy market that supplied local shopkeepers with goods and materials.

The thriving cosmopolitan community of Scranton included immigrants from Britain, Wales, Germany, Ireland, Italy, and eastern Europe, who animated the social and cultural fabric of the city. They brought with them Old World traditions and practices that survived in ethnic churches and social organizations. Informed by a desire to strengthen individuals and families, service agencies such as the Young Men's Christian Association, Saint Joseph's Foundling Home, and the House of the Good Shepherd also established outreach programs. Scranton answered the need for quality health care with the Lackawanna Hospital, later known as Scranton State Hospital, and other advanced medical facilities. The Lackawanna Historical Society's photographs of the Catherine Simpson Young Women's Christian Association, the Salvation Army distributing free coal, and the first operation at Moses Taylor Hospital stand as testimonies to these civic and charitable endeavors.

Arriving in Scranton to work, city residents also found ways to have fun. Numerous clubs offered outlets for tennis, canoeing, and bicycling. A lively theater district gave venue to traveling vaudeville shows, concerts, and lectures. Outdoor recreation areas such as Nay Aug and Luna Parks provided popular amusements including picnic areas and thrill rides. Many of these organizations and establishments have gone, but in the collection of the Lackawanna Historical Society, treasured objects such as bicycles and sophisticated opera glasses remind us of the delight they must have brought to those who lived and played here.

The mission of the Lackawanna Historical Society is to foster the knowledge and appreciation of the history and culture of Lackawanna County through educational programs, public accessibility to library materials and archival collections, and alliances with like-minded organizations. This book contributes to their on-going mission. Its text and images highlight only a small portion of the Lackawanna Historical Society collection, and an even smaller portion of the lived experience of the city of Scranton. Yet, they invite us to share in the spirit and strength that has characterized this community for the past 200 years.

One

EARLY SETTLEMENT

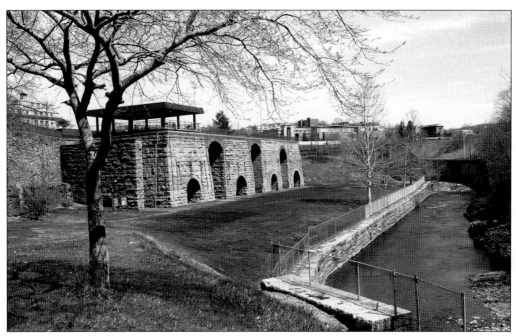

LACKAWANNA IRON FURNACES. In 1840, William Henry, Selden T. Scranton, and George W. Scranton established an iron furnace along Roaring Brook. The business faltered until 1847, when facilities expanded to produce "T" rails for the New York and Erie Railroad. Steel production began in 1875. The furnaces closed in 1902, relocating to Buffalo, New York. The Lackawanna Iron Furnaces were listed on the National Register of Historic Places in 1991 and are now maintained by the Pennsylvania Historical and Museum Commission.

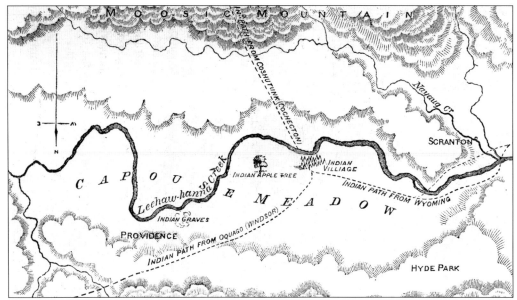

MAP OF NATIVE AMERICAN TRAILS. Long before European colonization, Native Americans occupied the region now known as northeastern Pennsylvania. During the 18th century, a group of Lenape-Monsey, displaced from lands to the south by the Walking Purchase of 1737, settled along the Lackawanna River at a site near present-day Weston Field. Their village, named Capouse Meadows in honor of their leader, Chief Capouse, could be reached by Native American paths from Oquago, Cochecton, and Wyoming.

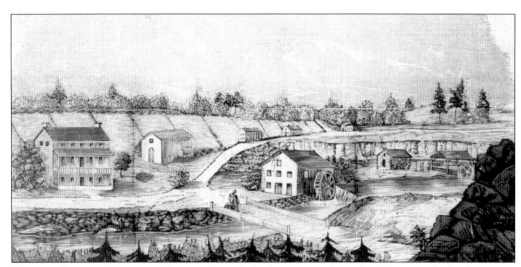

VIEW OF SLOCUM HOLLOW. During the early 19th century, the valley between the Lackawanna River and Roaring Brook was sparsely populated. Around 1788, Phillip Abbot of Connecticut built a home and gristmill there. John Howe purchased the property around 1790, selling it to Ebenezer and Benjamin Slocum in 1797. Between 1800 and 1828, the Slocum brothers operated an iron forge at the site. This illustration from Hollister's *History of the Lackawanna Valley* depicts the Slocum house, mill, and distilleries around 1840.

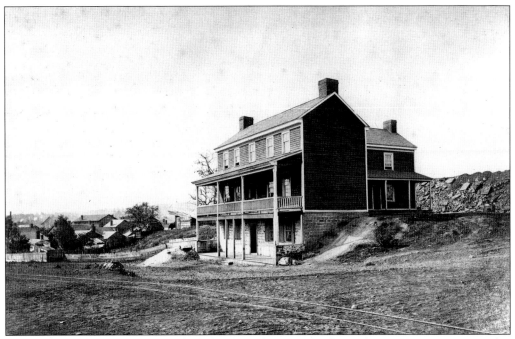

SLOCUM HOUSE. The homestead of Ebenezer Slocum, grandson of Isaac Tripp, is seen in this photograph from the late 19th century. Constructed in 1805 near Mattes Street, the building, known as the "Old Red House," was demolished in 1875.

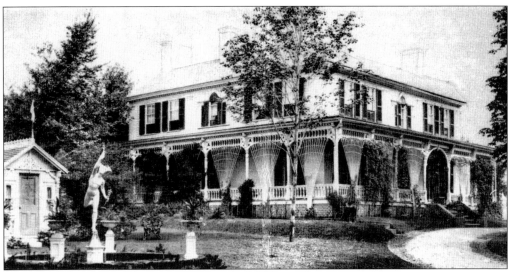

TRIPP HOUSE. Located at 1011 North Main Avenue on land deeded to Isaac Tripp in 1771, this house is the oldest in Scranton. Begun in 1788, the structure was enlarged by Isaac Tripp III in the Federal style in 1812, and remodeled by Col. Ira Tripp in the Victorian style around 1870. Shown here around 1890, the Tripp House was added to the National Register of Historic Places in 1972 and is maintained by the Junior League of Scranton.

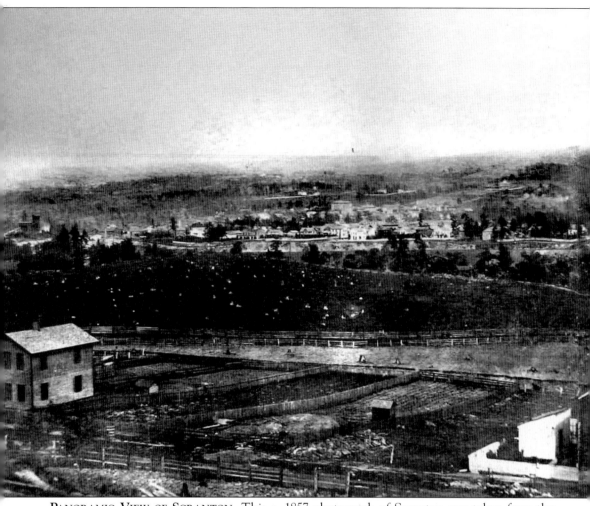

PANORAMIC VIEW OF SCRANTON. This c. 1857 photograph of Scranton was taken from the west side of the Lackawanna River, looking toward center city and the Delaware, Lackawanna and Western roundhouse, near the present-day Steamtown National Historic Site. A similar

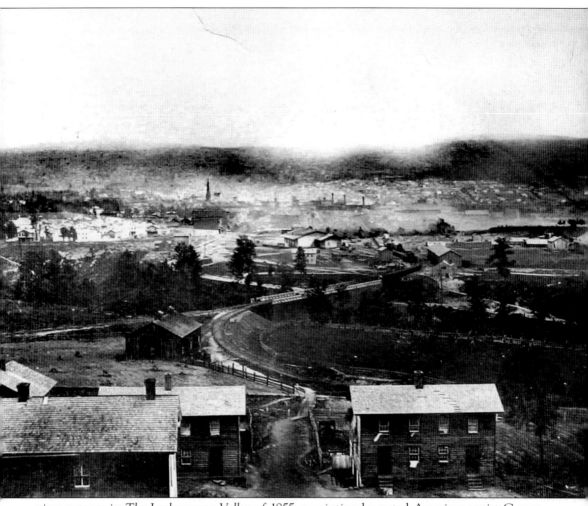
view appears in *The Lackawanna Valley of 1855*, a painting by noted American artist George Inness, now in the collection of the National Gallery of Art, Washington, D.C.

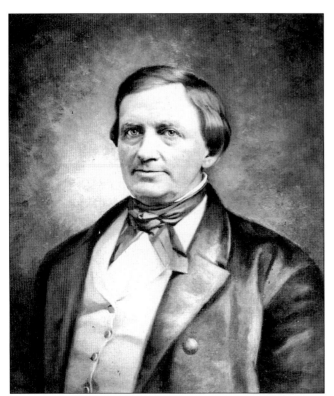

WILLIAM HENRY (1794–1878). William Henry was born in Stroudsburg, the son of a Moravian gunsmith. Trained as a geologist, he operated the Oxford Furnace in Belvidere, New Jersey, where in 1835 he became the first ironmaster in the country to use the hot-blast process. Henry traveled to Slocum Hollow in 1836. Impressed by the region's coal, iron, and water resources, he considered the location ideal for the construction of an iron furnace fueled by anthracite.

COL. GEORGE WHITFIELD SCRANTON (1811–1861). George W. Scranton came to Slocum Hollow from the Oxford Furnace with his brother Selden T. Scranton. Early setbacks at the Scrantons' fledgling iron company caused George to note, "I cannot stand trouble and excitement as I once could. I don't sleep good. My appetite is poor & digestion bad. . . . If we can succeed in placing Lacka. out of debt it would help me much." Popular in the local community, he helped to establish the Delaware, Lackawanna and Western Railroad, and was twice elected to Congress.

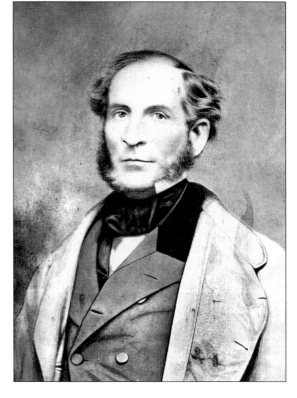

SELDEN THEOPHILUS SCRANTON (1814–1891). In 1840, William Henry, his son-in-law Selden T. Scranton, Selden's brother George W., and Sanford Grant, a merchant from Belvidere, New Jersey, purchased 503 acres in Slocum Hollow for $8,000. Later that year, they formed Scrantons, Grant, and Company and began construction of a furnace. Like his father-in-law, Selden T. Scranton had worked at the Oxford Furnace, serving as superintendent. After helping to establish the furnaces at Lackawanna, he returned to Oxford in 1858.

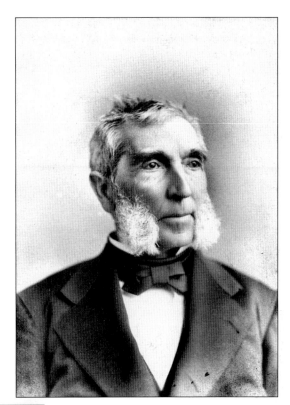

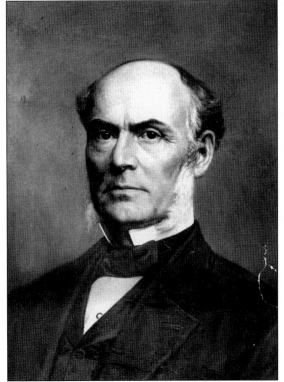

JOSEPH HAND SCRANTON (1813–1872). Cousin to Selden T. and George W. Scranton, Joseph H. Scranton of Augusta, Georgia, invested in the firm of Scrantons, Grant, and Company in 1843. By the 1860s, Selden T. and George W. were no longer residents of the city bearing their name. Joseph H., however, remained to become patriarch of a wealthy family whose descendants included William Walker Scranton (1844–1916), Worthington Scranton (1876–1955), and William Warren Scranton (b. 1917), governor of Pennsylvania from 1963 to 1967.

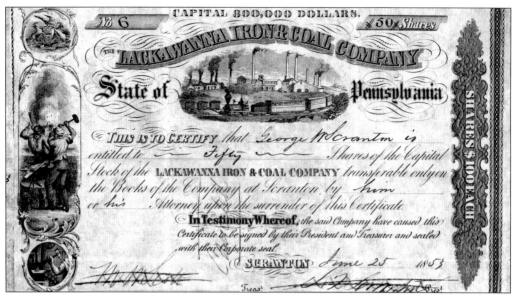

COAL COMPANY SHARE CERTIFICATE. In 1846, Joseph C. Platt replaced Sanford Grant as store manager, and Scrantons, Grant, and Company reorganized as Scrantons and Platt. In 1847, on the verge of bankruptcy, the company signed a contract with the New York and Erie Railroad for the production of iron "T" rails. Investments for two additional furnaces were secured, and the company established mining and railroading interests. In 1853, some 8,000 shares of stock were issued, and the Lackawanna Iron and Coal Company was formed.

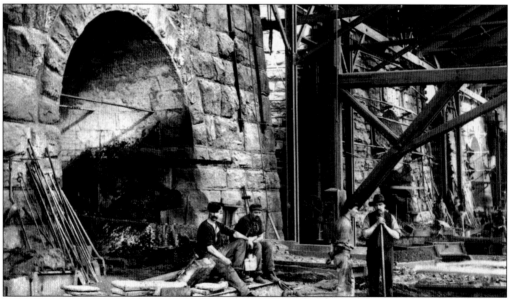

COMPANY WORKERS. During the 1840s, the founders of the Lackawanna Furnaces struggled to manufacture and market iron products. They first produced pig iron, but prices were low and shipping costs high. Next, they made nails, which were of poor quality. Iron "T" rails proved to be the company's saving grace. Lackawanna Iron and Coal Company laborers fabricated rails by passing iron ore through blast furnaces, puddling furnaces, and rolling mills. This mid-19th-century photograph shows workers outside a blast furnace casting arch.

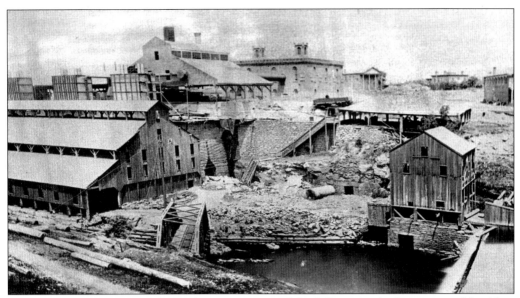

BLAST FURNACE. By 1857, the Lackawanna Iron and Coal Company had constructed five blast furnaces, each with a funnel-shaped stone chimney, which was filled with layers of coal, iron ore, and limestone. This mixture was heated, and molten iron collected at the bottom of the stack, or hearth. Airpipes, called tuyeres, passed through archways at the back and sides of the stack. Molten iron was released, or tapped, from the furnace and flowed through a front casting arch. Outside, it cooled into "pigs" in a bed of sand.

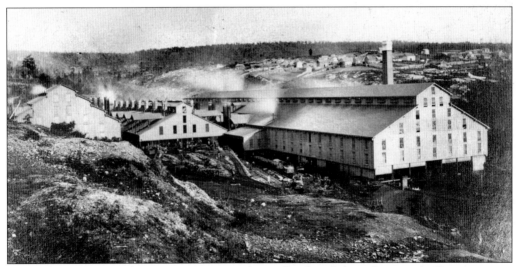

ROLLING AND PUDDLING MILLS. Iron was then refined and shaped into rails. First, iron pigs were reheated in an oven. As they melted, the pigs were stirred to remove excess carbon. The iron was gathered into a ball, or bloom, and passed through a squeezer to remove impurities, or slag. The iron was then hammered and forge-welded into a billet, which was squeezed through rollers to form a "T" profile.

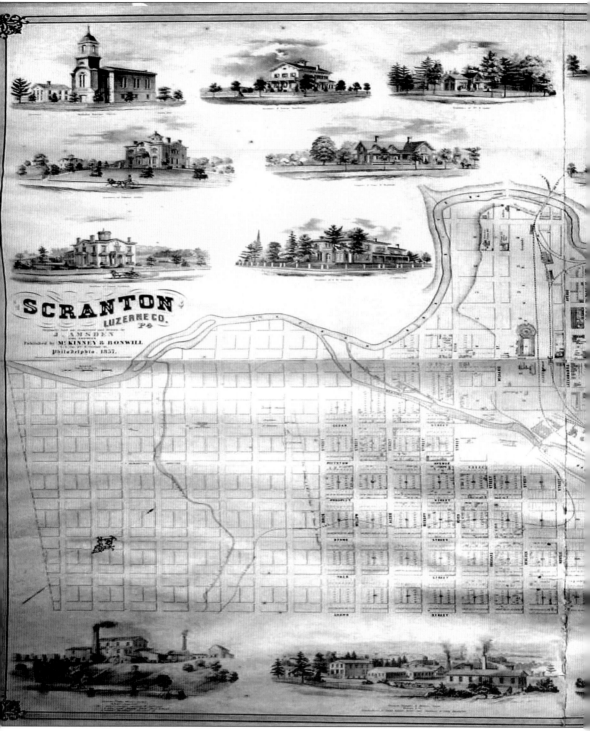

AMSDEN'S MAP OF SCRANTON. Drawn by Joel Amsden (1812–1868), this beautifully rendered map was published by McKinney and Bonwill of Philadelphia in 1857. A civil engineer, Amsden laid out the city, re-surveyed the land, arranged streets in a grid stemming from Lackawanna and

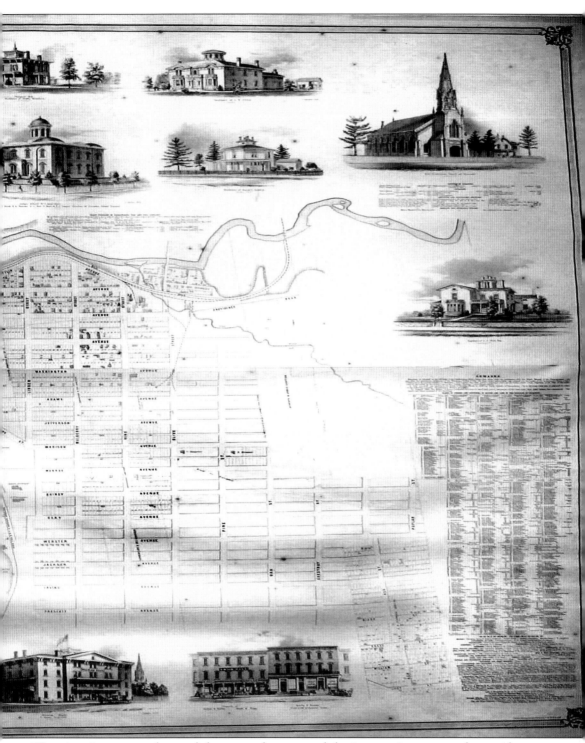

Wyoming Avenues, and named the streets for trees and the intersecting avenues for presidents. The map lists businesses and property owners and depicts many views "drawn from Nature" by C. E. H. Bonwill.

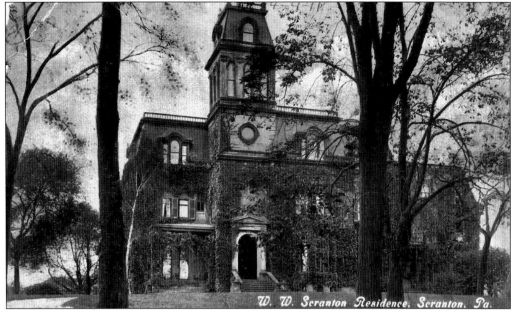

RESIDENCE OF JOSEPH H. SCRANTON. Designed in the French Second Empire style by Russell Sturgis Jr. and built of locally quarried granite, the mansion featured wall coverings by William Paris. The Scranton family patriarch celebrated Thanksgiving of 1872 in his new home but died in Baden-Baden, Germany, where he had gone to recuperate from an illness, shortly thereafter. The house remained in the family until 1941, when it was donated to the University of Scranton.

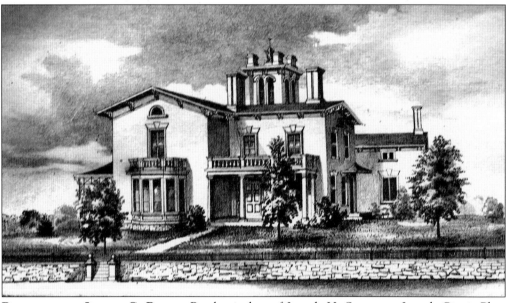

RESIDENCE OF JOSEPH C. PLATT. Brother-in-law of Joseph H. Scranton, Joseph Curtis Platt (1816–1887) was a merchant from New Haven, Connecticut, who came to Scranton in 1846 as manager of the Scrantons' company store. Platt Place, located at Ridge Row and Jefferson Avenue, was designed by Joel Amsden in 1857. A real-estate agent, Platt helped Amsden name Scranton's streets. He was involved with the Delaware, Lackawanna and Western Railroad and Dickson Manufacturing, among other enterprises.

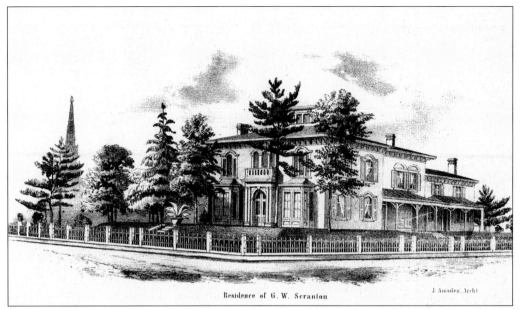

RESIDENCE OF GEORGE W. SCRANTON. Designed by Joel Amsden in the Italianate style, the George W. Scranton house, located at Lackawanna and Adams Avenues, was constructed in 1857. The building, pictured here as an illustration from Amsden's *Map of Scranton*, remained in the family until the early 1900s. By 1910, it had been demolished and the Hotel Casey erected in its place.

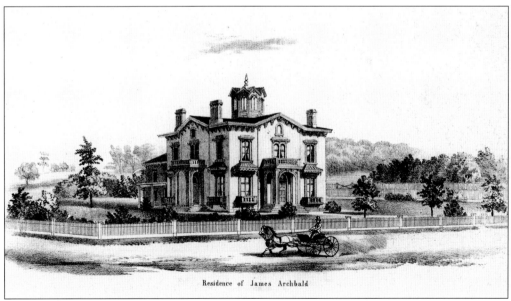

RESIDENCE OF JAMES ARCHBALD. Born in Ayreshire, Scotland, James Archbald (1793–1870) emigrated to the United States in 1805. In 1817, he worked on the construction of the Erie Canal and, in 1829, came to Carbondale to design the Delaware and Hudson Canal and Gravity Railroad. As general agent and chief engineer of the Delaware, Lackawanna and Western Railroad, he relocated to Scranton in 1857. His home at Ridge Row and Monroe Avenue, designed by Joel Amsden, was built and pictured on Amsden's *Map of Scranton* that year.

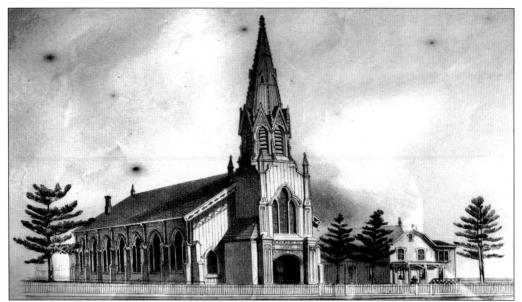

First Presbyterian Church. To meet the spiritual needs of the growing community, the Scrantons and their wives, along with several others, organized the First Presbyterian Church in 1848 and met in the Odd Fellows Hall at Lackawanna and Jefferson Avenues and Ridge Row. Later, Amsden designed this building, completed in 1853. Located at 115 North Washington Avenue on property donated by the Scrantons and Platt, the Victorian Gothic wooden structure seated 800 people.

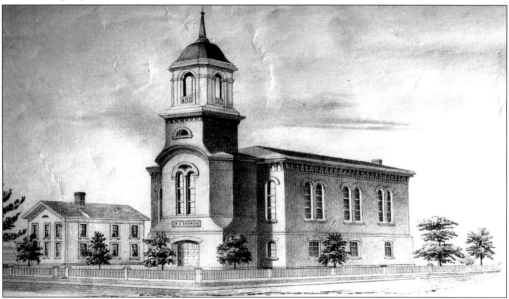

Methodist Episcopal Church. The congregation of the Methodist Episcopal Church was first organized in 1843. This building, known as the Adams Avenue Church, was designed by Joel Amsden and erected between 1856 and 1859 on land donated by the Lackawanna Iron and Coal Company. In 1891, the Adams Avenue Church was sold as the congregation prepared to construct new facilities on a triangular lot near Linden Street and Jefferson and Madison Avenues, known today as the Elm Park United Methodist Church.

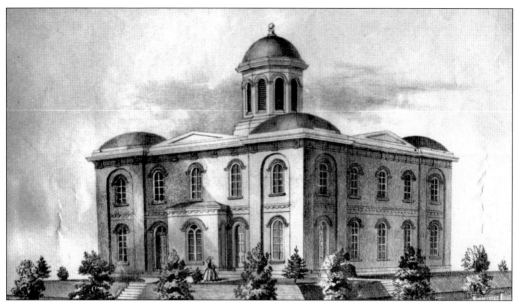

Public School No. 1. Designed by Amsden, this structure, as noted on his map of Scranton, was built in 1857 "under the superintendence of Wm. H. Jenks, J. W. Brock, H. L. Marvine, A. L. Horn, J. Grier and P. J. Coyne, directors of the Scranton School District." The Scranton school system at this time included the high school and five one-room schools scattered throughout the city. Located at North Washington Avenue and Vine Street, this building was replaced in 1896 by Scranton Central High School.

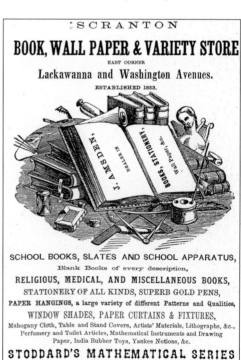

Amsden's Book and Variety Store. Born in Hartland, Vermont, and trained in civil engineering at Norwich Military University, Joel Amsden came to Scranton in 1850. As an engineer for the Lackawanna Iron and Coal Company, Amsden surveyed portions of the Delaware, Lackawanna and Western Railroad, planned downtown Scranton, designed numerous public buildings and private residences, and operated this book and variety store at Lackawanna and Washington Avenues, selling books, stationery, and artists' supplies.

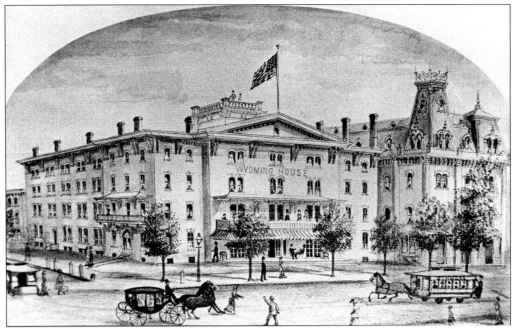

WYOMING HOUSE. As its iron, coal, and railroad interests grew, the Lackawanna Iron and Coal Company saw that Scranton would benefit from the construction of a first-class hotel. Designed by Joel Amsden and completed in 1852, this three-story brick building was located at Wyoming and Lackawanna Avenues. Among its various proprietors were S. Bristol and John C. Burgess. The hotel closed in 1896, and was razed to make way for the Jonas Long's and Sons department store.

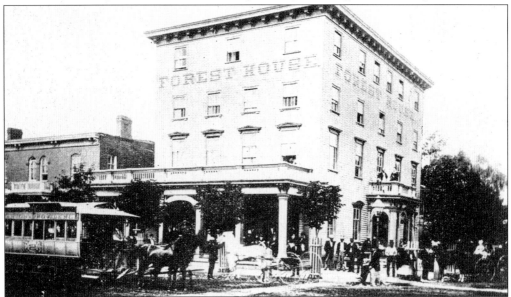

FOREST HOUSE. First run as a boardinghouse, this hotel at Wyoming Avenue and Spruce Street was built by George R. Sprague around 1855. Originally three stories, it was purchased in 1857 by Joseph Godfrey, who added a fourth floor. The building was sold by N. G. Schoonmaker to John Jermyn, who demolished it in 1894 to build the Hotel Jermyn in its place. The Forest House is shown here around 1870.

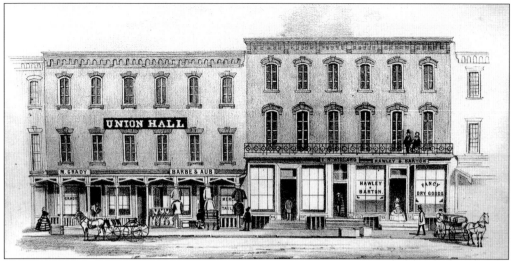

SCRANTON STOREFRONTS. These illustrations of the storefronts at 118 and 120 Lackawanna Avenue are found on Amsden's 1857 *Map of Scranton*. They depict the Union Hall, owned by Carling and Griffin, as well as offices owned by Grant and Tripp. Businesses operating in these structures included M. Grady's Dry Goods and Grocery, Barbe and Aub Clothing and Merchant Tailors, E. N. Willard Attorney at Law, and Hawley and Barton Fancy Dry Goods.

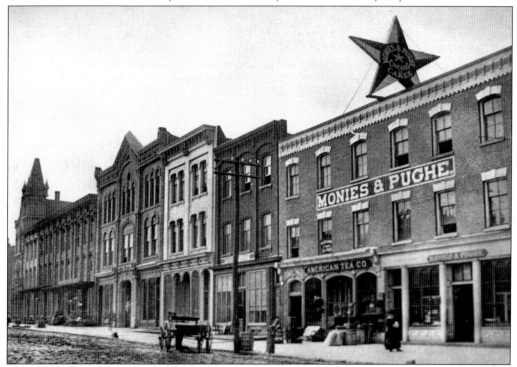

MONIES AND PUGH STAR BAKERY. Bakeries were essential to the growing community. Established by William N. Monies and Lewis Pugh in 1866, this bakery, located at 502–504 Lackawanna Avenue, made Star crackers, cakes, and confections. The 1875 Scranton City Directory points out that the bakery used new steam technology to bake bread. Also shown in this *c.* 1875 photograph is the Old German Odd Fellows Hall at 522 Lackawanna Avenue.

DECKER'S BLACKSMITH SHOP. In its early days, the city of Scranton did not spread beyond an area that could be traversed by horse. In the days of horse and buggies, blacksmiths were much in need. For many years, the Decker family operated shops in the Scranton vicinity. Shown in this 19th-century image are, from left to right, Fred Decker, Mr. Phillips, and Martin Decker.

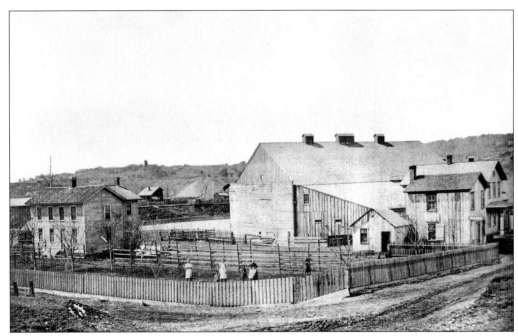

SCHADT'S ICE HOUSE. Before refrigeration, homes and businesses used ice to preserve food. Companies harvested and stored ice during the winter for delivery throughout the year. This 1876 photograph depicts, from left to right, a residence at 344 Locust Street, Stafford Meadow Brook, Schadt's Ice House, and the John Scheuer Bakery.

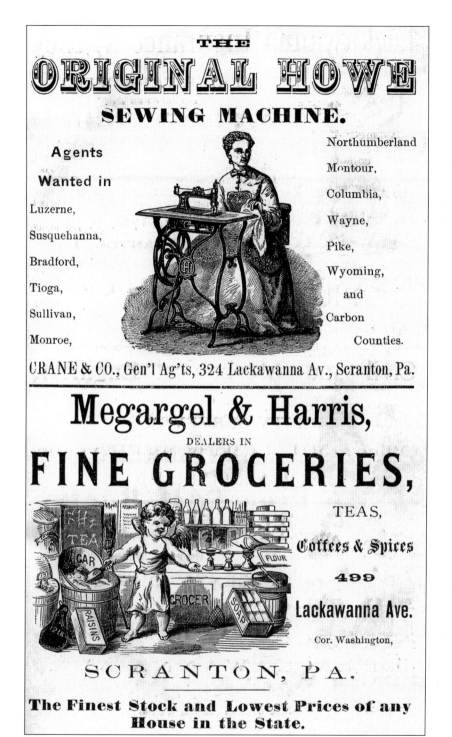

SCRANTON DIRECTORY ADVERTISEMENTS. This page, taken from the 1870 Scranton City Directory, indicates the diversity of businesses operating in the city. Crane and Company, located at 324 Lackawanna Avenue, sought general agents for the Original Howe Sewing Machine, while Megargel and Harris sold fine groceries at 499 Lackawanna Avenue.

VIEW OF JOSEPH H. SCRANTON RESIDENCE OVERLOOKING RAIL LINE. Located on a hillside in the upscale Ridge Row neighborhood, the Joseph H. Scranton residence offered its owner a view of his investments, including the Lackawanna Coal and Iron Company and the Delaware, Lackawanna and Western Railroad. The home and rail line are seen here in the 19th century.

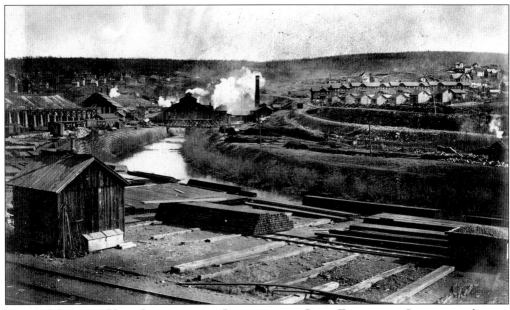

VIEW OF SHANTY HILL OVERLOOKING LACKAWANNA IRON FURNACES. Scranton industries attracted people from around the world. In 1847, the Lackawanna Iron Furnaces employed some 800 workers, many of Welsh, Irish, English, and German descent. Workers were first granted squatters' rights to construct shanties in the nearby south side. Company housing, as shown in this 19th-century photograph, eventually included row homes and single dwellings. By 1852, some 3,000 residents lived in the vicinity of the furnaces.

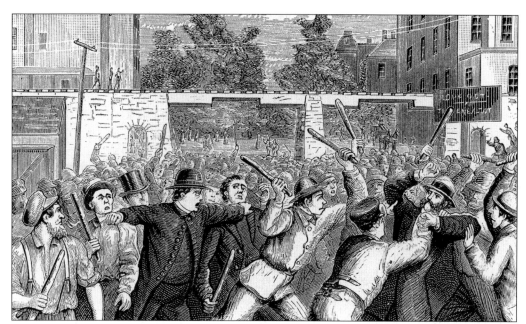

STRIKE OF 1877. In 1877, national labor strikes affected many industrial centers, including Scranton, where a widespread strike against railroads caused a 10-percent wage cut in the steel mills. On August 1, 1877, strikers marched up Lackawanna Avenue and were met at the corner of Washington Avenue by a group that included Mayor Robert McCune. During the ensuing riot, the mayor's jaw was broken, three people were killed, and 25 people were wounded.

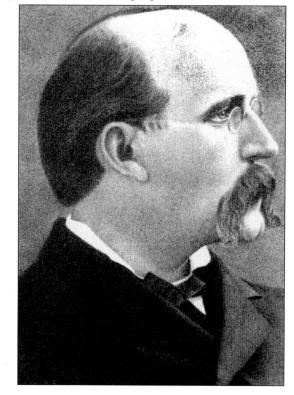

TERENCE V. POWDERLY. A machinist from Carbondale, Powderly helped to organize Scranton's Greenback-Labor Party in the wake of the 1877 strike. A member of the Knights of Labor, he became mayor of Scranton on November 6, 1877, and served three terms. Political power shifted as Lackawanna County broke from its parent Luzerne County during Powderly's term. On August 21, 1878, the new county was officially declared, with Scranton as its county seat.

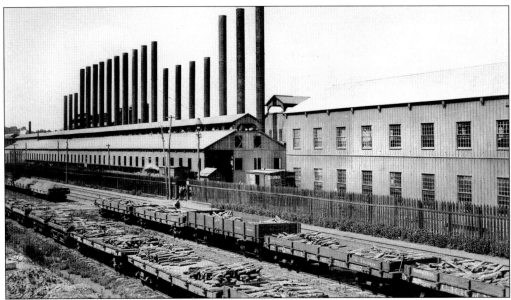

SCRANTON STEEL COMPANY. The Lackawanna Iron and Coal Company's board of directors rejected an 1881 expansion proposal by general manager William Walker Scranton, and the Yale-educated son of Joseph H. Scranton resigned his post to organize the Scranton Steel Company. By 1890, the company's two 6-ton Bessemer converters were producing 250,000 net tons of ingots yearly. In this c. 1886 photograph of the plant, flat cars are loaded with pig iron to be processed into steel.

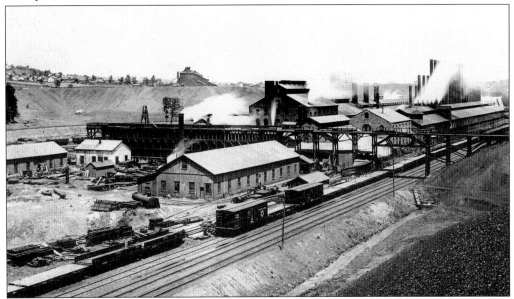

SOUTH STEEL WORKS. The Lackawanna Iron and Coal Company and the Scranton Steel Company merged in 1891 to become the Lackawanna Iron and Steel Company. The third largest steel works in the country in 1894, it produced 500,000 tons of steel rail—one-sixth the national output. This c. 1894 photograph shows the company's Bessemer converters, known as the South Works. In 1902, the company relocated to Lackawanna, New York, to take advantage of shipping routes on Lake Erie.

Two

Industrial Development

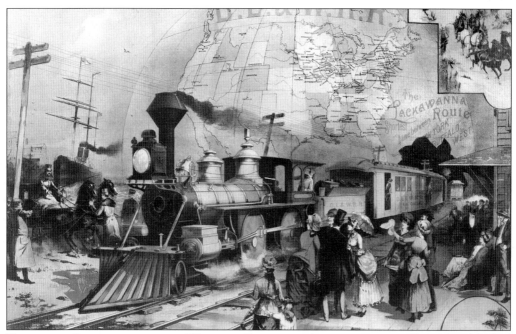

Delaware, Lackawanna and Western Railroad Advertisement. The railroad linked the country in a way that had never before been known. Locally, the industry flourished. In 1850, the Delaware, Lackawanna and Western Railroad was formed by the merger of the Leggett's Gap and Delaware and Cobb Railroads. Between 1850 and 1950, it enjoyed a reputation as one of the best run in the nation. This early-20th-century advertisement shows the importance of the railroad to nationwide transportation.

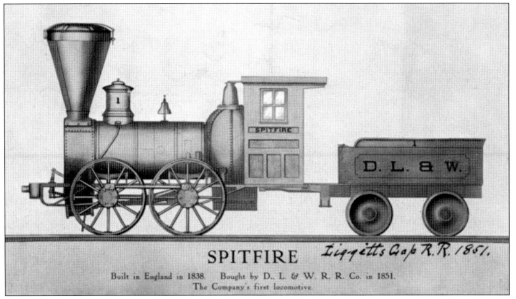

Delaware, Lackawanna and Western Railroad's "Spitfire" Engine. Built in Great Britain in 1838, the "Spitfire" was the first engine purchased by the Delaware, Lackawanna and Western Railroad in 1851. Initially used for construction work at the Lackawanna Iron Furnaces, it hauled a train of 65 passengers from Great Bend to Scranton on October 15, 1851, to mark the official opening of the railroad.

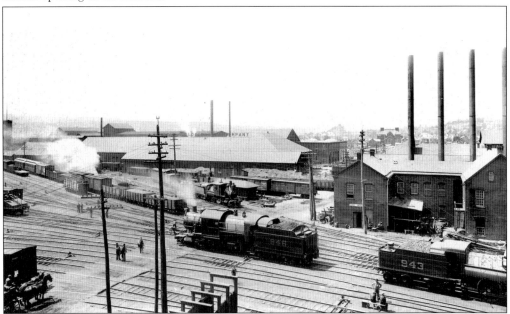

Delaware, Lackawanna and Western Railroad Yards and American Locomotive Company. This c. 1902 photograph shows the Delaware, Lackawanna and Western Railroad yards near Cliff Street. The long building is the American Locomotive Company, originally called the Cliff's Works of Cooke and Company, a New York firm. Purchased by the Dickson Manufacturing Company in 1862, the structure was enlarged in 1864. The Sall Mountain Company, Quakenbush Warehouse Company, and Scranton Silk Company were later located there.

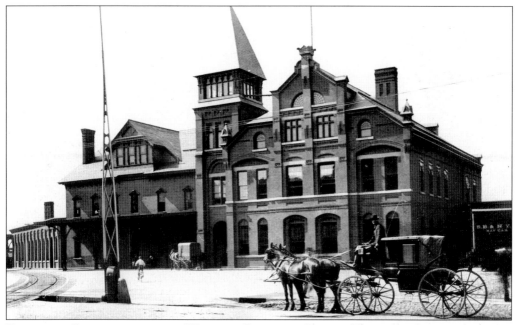

DELAWARE, LACKAWANNA AND WESTERN RAILROAD DEPOT. This early photograph depicts the Delaware, Lackawanna and Western Railroad passenger depot, built in 1864. Located on Lackawanna Avenue, facing Franklin Avenue and Mifflin Streets, the structure was razed in 1902, after completion of the new passenger station at Lackawanna and Jefferson Avenues. A freight station was then erected on the site.

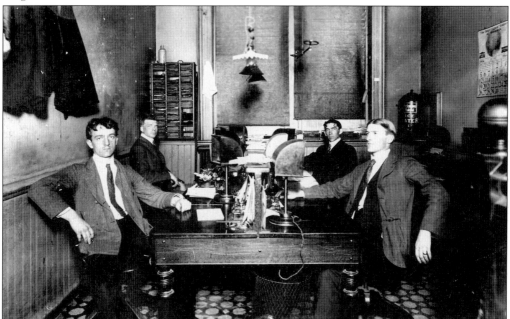

DELAWARE, LACKAWANNA AND WESTERN RAILROAD DISPATCH OFFICE. The dispatch office of the Delaware, Lackawanna and Western Railroad is pictured here in 1904. The man seated at right is chief dispatcher George Secor. At this time, messages were sent via Morse Code. Later, wireless transmissions, or radio, and telephones were used.

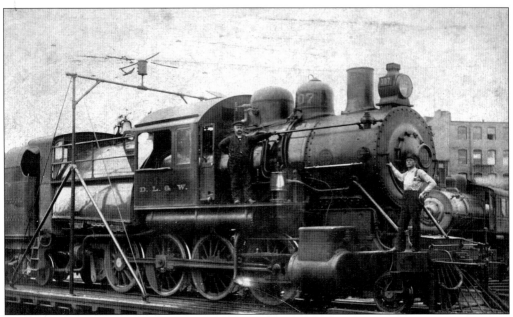

JACOB H. SCHAFFER AND NO. 307. Built by Danforth and Cooke in 1882, Engine No. 307, previously numbered 45, was a 2-6-0 locomotive weighing 93,000 pounds. It was assigned to the Buffalo Division and sold in 1903 to the Fitzhugh-Luther Company, a dealer in Delaware, Lackawanna and Western equipment. Engineer Jacob H. Shaffer poses with No. 307 in this late-1800s photograph.

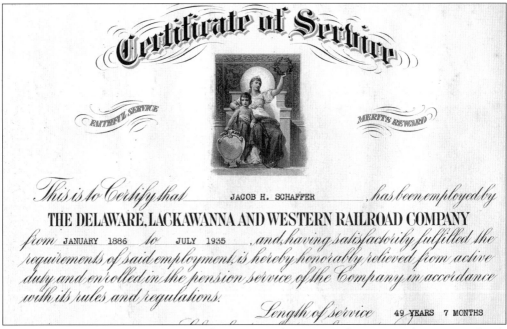

SCHAFFER CERTIFICATE OF SERVICE. After a career of 49 years and seven months, engineer Jacob H. Shaffer retired from the Delaware, Lackawanna and Western Railroad. He was awarded this certificate of service, signed by Marcus Davis, who served as company president from July 1, 1925 to December 31, 1940. Around 1902, the railroad adopted a pension plan for retirees.

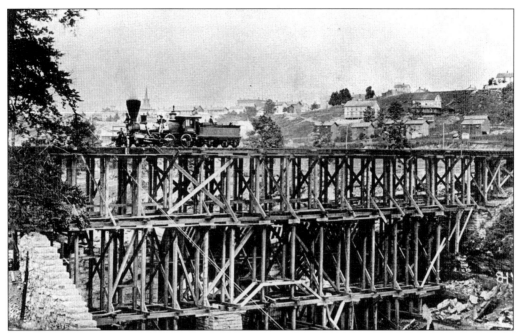

WOODEN TRESTLE OVER LACKAWANNA RIVER. Taken in 1866, this photograph shows the wooden trestle constructed by the Delaware, Lackawanna and Western Railroad across the Lackawanna River near Cliff Street. In the left foreground is the stone pier, the beginning of the stone bridge that would replace this wooden structure.

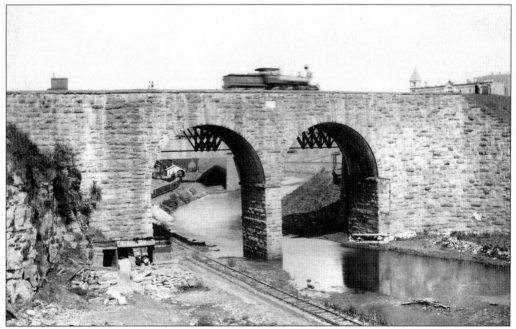

STONE TRESTLE OVER LACKAWANNA RIVER. The stone arch bridge shown in this 19th-century photograph replaced the wooden railroad trestle shown above. In 1911, the Delaware, Lackawanna and Western Railroad stone bridge was supplanted by a steel trestle. Known as Bridge 60, it is still in use today.

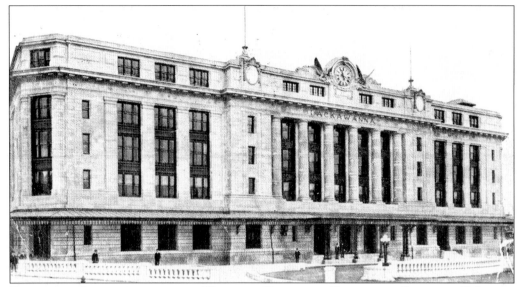

DELAWARE, LACKAWANNA AND WESTERN RAILROAD PASSENGER STATION. Delaware, Lackawanna and Western Railroad president William Truesdale authorized the construction of a new passenger station at Scranton in the early 1900s. Designed by New York architect Kenneth Murchison in the French Renaissance style, the building, completed in 1908, replaced the old brick station at the opposite end of Lackawanna Avenue. The station closed in 1970, but was reopened as a hotel in 1983. In 1995, under new ownership, it became the Radisson Lackawanna Station Hotel.

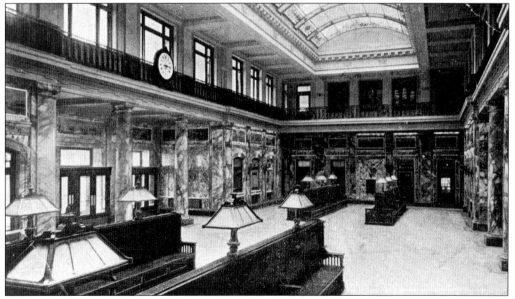

DELAWARE, LACKAWANNA AND WESTERN RAILROAD PASSENGER STATION INTERIOR. Considered one of the most beautiful in the country, the interior of the Delaware, Lackawanna and Western Railroad passenger station boasted a stately waiting room two and a half stories tall, featuring walls of Sienna marble and a barrel-vaulted ceiling with a leaded glass skylight. A series of Voorhees faience panels depicted scenes along the railroad's route between Hoboken, New Jersey, and Buffalo, New York.

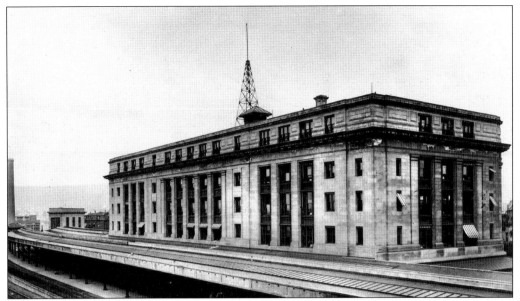

DELAWARE, LACKAWANNA AND WESTERN RAILROAD STATION AND SHEDS. On the track side of the Delaware, Lackawanna and Western Railroad passenger station, the canopies of a Bush train shed, pictured in this early-20th-century image, provided a shelter for loading and unloading. A wireless antenna is visible on the roof of the station. The Marconi Company developed the equipment, and the railroad pioneered the use of wireless transmissions between trains and terminals, with broadcasting towers in New York City and Buffalo.

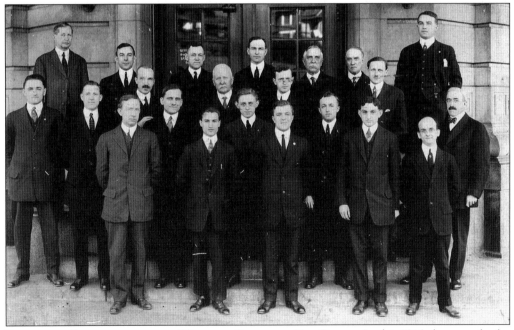

DELAWARE, LACKAWANNA AND WESTERN RAILROAD PAY OFFICE. In this 1916 photograph, the staff of the Delaware, Lackawanna and Western Railroad pay office pose outside the passenger station. All offices of the railroad were located in the six-story train station, with the exception of the executive offices in New York City. Frank Hallstead served as paymaster at this time.

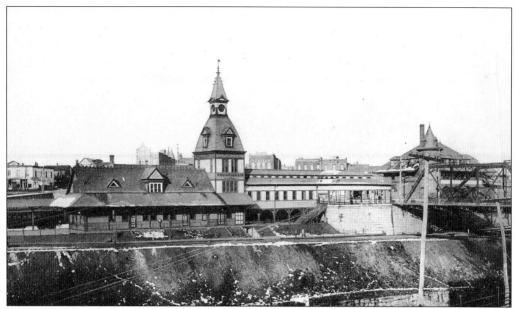

CENTRAL RAILROAD OF NEW JERSEY DEPOT. The Central Railroad of New Jersey accessed the Scranton market by leasing Lehigh and Susquehanna Railroad property in 1866. The Central Railroad of New Jersey abandoned the original depot on Bridge Street and built this passenger station in 1889. Also shown in this photograph are the tracks of the New York, Ontario and Western Railway Company, which used the station as a southern terminus.

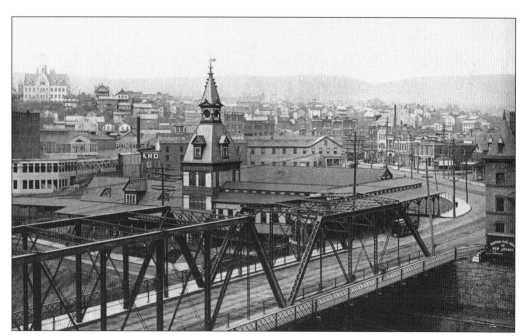

VIEW OF CENTRAL RAILROAD OF NEW JERSEY WITH BRIDGE. This photograph provides an excellent view of Scranton's lower west side, including the Central Railroad of New Jersey's passenger station and freight house, and the Lackawanna Avenue Bridge. This steel bridge replaced a wooden one originally connecting Scranton's business district with the west side of town.

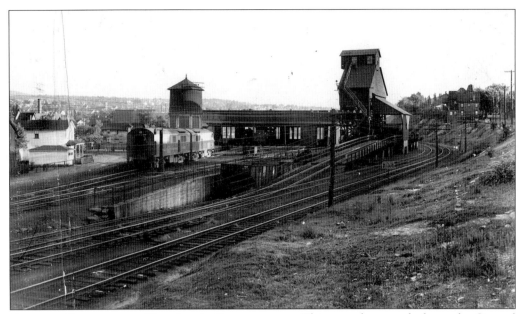

CENTRAL RAILROAD OF NEW JERSEY ROUNDHOUSE. This rare photograph shows the Central Railroad of New Jersey roundhouse, located in the Bellevue section of Scranton near the present-day William T. Schmidt ball field. The roundhouse was built in 1888, the year the railroad began operations in Scranton. It survived until the flood of 1955 devastated this section of the city.

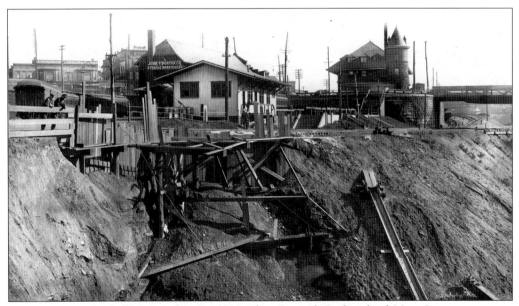

CONSTRUCTION OF BRIDGE 60. In 1910, the Central Railroad of New Jersey passenger station was destroyed by fire and replaced with a much smaller building, shown here in 1911. The construction of piers for the Delaware, Lackawanna and Western Railroad's Bridge 60 is also pictured. This steel bridge replaced the wooden trestle and stone arch bridges previously constructed across the Lackawanna River. The Central Railroad of New Jersey discontinued passenger service in the 1950s.

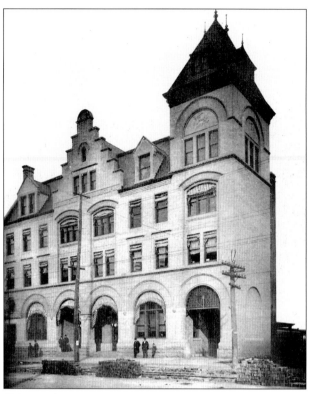

DELAWARE AND HUDSON RAILROAD DEPOT. The Delaware and Husdon Railroad Company began in 1823 as a network of canals serving New York and Pennsylvania, to which a gravity railroad was added in 1829. The company later expanded to become a full-scale railroad, and constructed this passenger station at 37 Lackawanna Avenue in 1899, pictured here around 1906. During the 1900s, some 34 daily trains served Wilkes-Barre, Scranton, Carbondale, and Honesdale. Service ended in 1951, and the passenger station was razed.

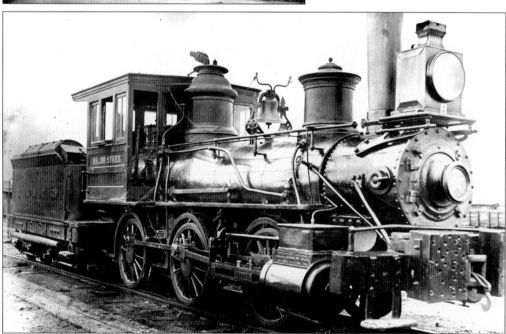

DELAWARE AND HUDSON RAILROAD'S "MAJOR SYKES" ENGINE. The "Major Sykes" was a 0-4-0 type locomotive built by the W. Cook Company in 1860 and used by the Delaware and Hudson Canal Company Gravity Railroad. In 1871, it collided with Engine No. 11 and wrecked. It was rebuilt in 1872 as a 0-6-0 and finally stopped running in 1889.

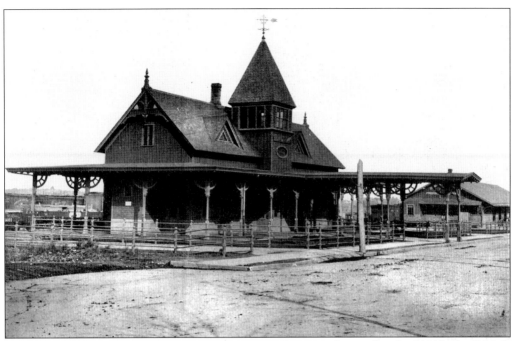

ERIE AND WYOMING VALLEY RAILROAD PASSENGER STATION. Located in the 700 block of North Washington Avenue, the Erie and Wyoming Valley Railroad passenger station was one of many fine railroad facilities that served Scranton. Note the freight house in the extreme right of this late-1800s photograph. In 1908, this Victorian-style structure was replaced by a concrete station.

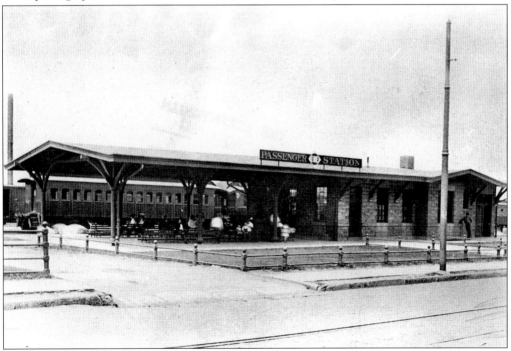

ERIE AND WYOMING VALLEY RAILROAD DEPOT. Built in 1908 on the site of the old passenger station, this building now serves as Cooper's Seafood Restaurant.

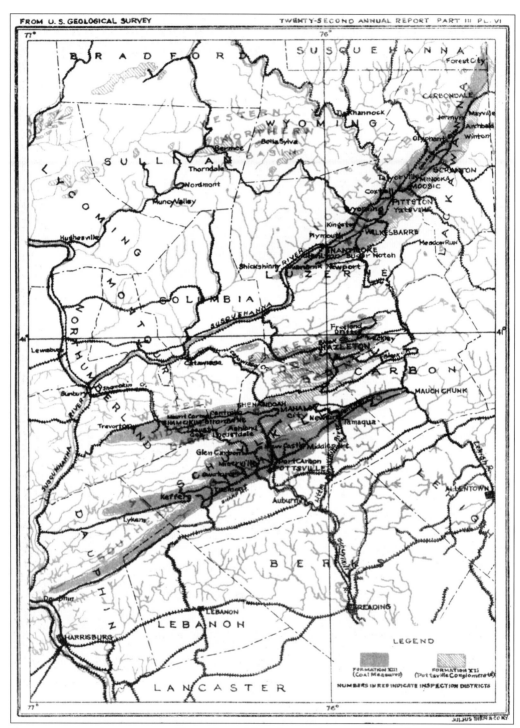

PENNSYLVANIA ANTHRACITE COAL FIELD MAP. In northeastern Pennsylvania, coal and the railroads existed in a symbiotic relationship that formed the foundation of a strong and growing economy. Some 33 mines operated in Scranton alone. This United States geological survey map shows the region's four anthracite coal fields, which totaled 484 square miles in nine counties.

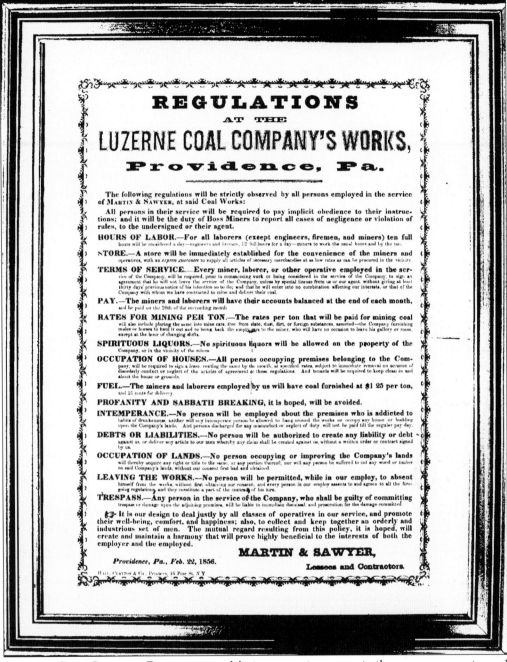

LUZERNE COAL COMPANY REGULATIONS. Mining operations were similar across companies and were fraught with danger. On February 22, 1856, the Luzerne Coal Company, located in what would become the Providence section of Scranton, issued work regulations to its employees. In a practice not uncommon at the time, the company forbid, among other things, the consumption of spirituous liquors, profanity, Sabbath-breaking, and trespassing.

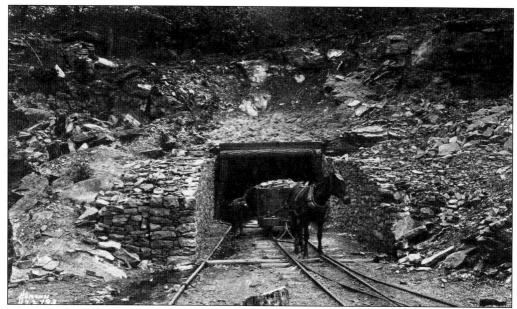

MULE AT ENTRANCE TO SLOPE MINE. Coal production was a multi-step process. During the 19th century, mules pulled coal cars in and out of mines. Here, a mule and car are shown at the entrance to a mountain tunnel at the Pine Ridge Mine. An opening, driven almost horizontally through beds of rock and coal, formed a slope mine. As the tunnel penetrated the coal beds, other passageways were driven from it.

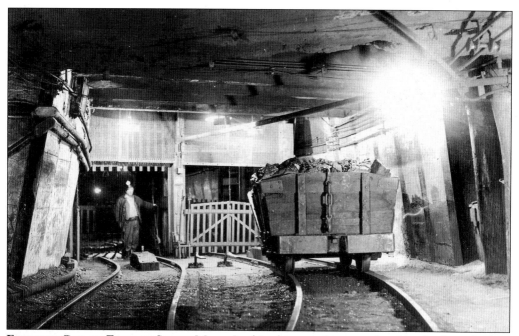

ELECTRIC CAR AT FOOT OF SHAFT MINE. In this photograph, a car of coal at the foot of a deep shaft mine waits to be hoisted to a colliery for preparation. In deep shaft mining, openings were driven vertically into underground coal beds so that access required the use of a mechanical lift. Many cars, lined on tracks leading to the lift, were alternately hoisted in two lift cages.

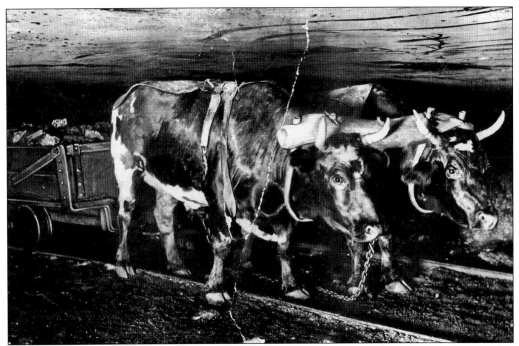

MINER'S OXEN. During the early days of the mining industry, coal cars were moved using manual labor. After 1860, this task was accomplished using oxen. Later in the century, oxen were replaced by mules, better suited to the climate and conditions in the mines. This *c.* 1860 photograph was taken at the Hudson Coal Company's Coalbrook Colliery. The Hudson Coal Company was later known as the Blue Coal Company Corporation.

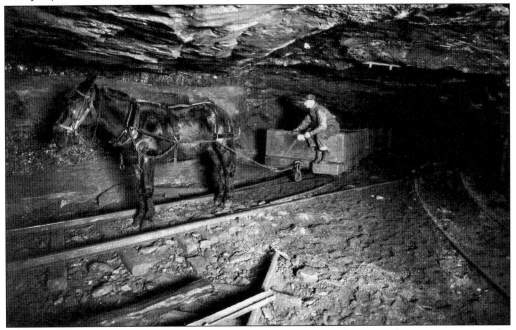

MINER'S MULE. This mule, shown with empty coal cars, served in the mines for 28 years. During the early 1900s, the use of mules was discontinued, and mine cars were hauled by electric locomotives.

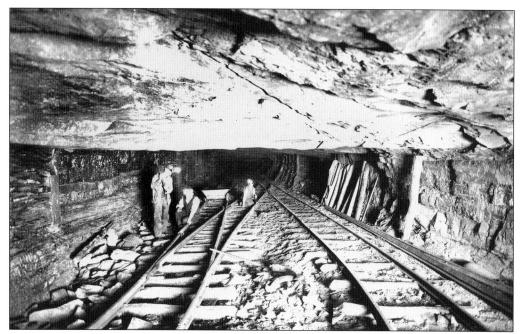

PREPARING UNDERGROUND TRACK. Inside the mines, coal cars traveled on underground systems of narrow gauge track. A track foreman oversaw all construction and maintenance on these transportation lines. In this image, men prepare underground track for coal cars. The main gangway, shown here, splits in two.

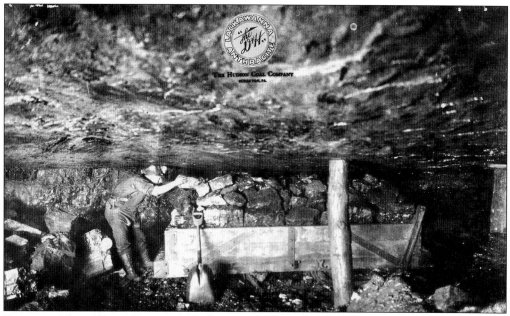

LOADING MINE CAR. Promotional photographs like this one, taken by early-20th-century photographer John Horgan for the Delaware and Hudson Coal Company, were often commissioned by coal firms to document their operations. This image shows a loaded coal car from a Delaware and Hudson Coal Company mine. Extra coal is heaped above the sides of the car in a practice known as topping.

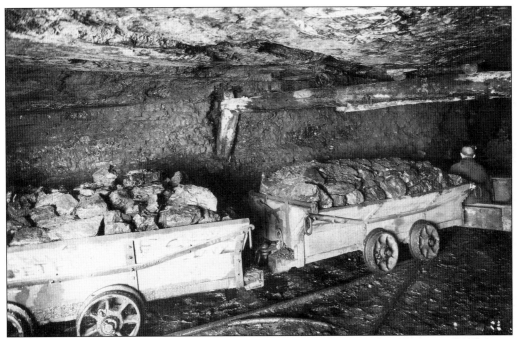

COAL CARS IN DUNMORE VEIN. An electric locomotive pulls loaded coal cars in this Horgan promotional photograph, taken in the top Dunmore vein of a Delaware and Hudson Coal Company mine.

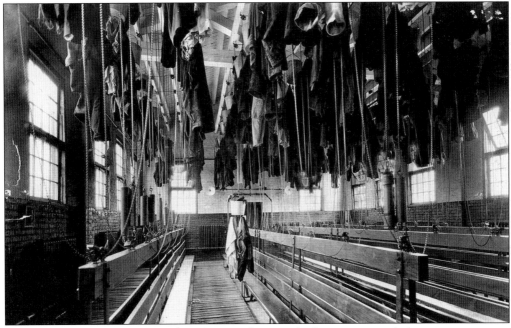

MINERS' CHANGING ROOM. This Horgan photograph shows a miners' changing room at a Delaware and Hudson Coal Company colliery. When miners began and finished work, they changed their clothes and hung up the soiled ones. The clothes were then hoisted to the ceiling for airing.

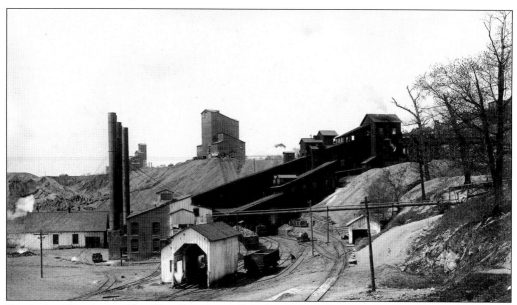

DIAMOND COLLIERY. The 27 collieries, or "breakers," in Scranton processed coal. George W. Scranton built the old Diamond Colliery about 1854; it was likely the first in the region. From 1859 to 1910, it produced 13,661,232 tons of anthracite. In 1910, it employed 271 miners, 271 laborers, 239 inside company men, and 202 outside company men. This c. 1910 image also shows the Delaware, Lackawanna and Western's new Diamond Colliery, built in 1907. The independently operated Mount Pleasant Breaker sits to the left.

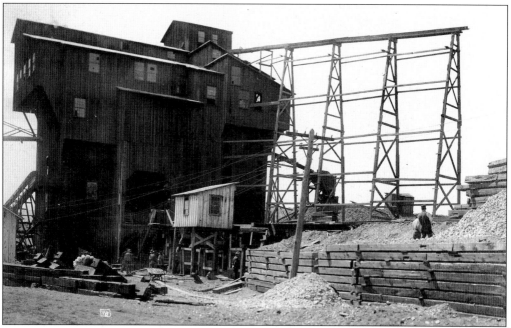

DIAMOND WASHERY. One of the coal-processing facilities owned by the Delaware, Lackawanna and Western Railroad Coal Department, the Diamond Washery began production in March 1900. By December 31, 1910, the facility had processed 1,859,270 tons of coal. Average daily production in 1910 was 545 tons, while the average number of employees was 49.

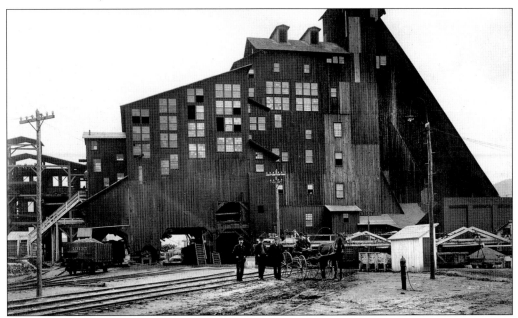

CAYUGA COLLIERY. The Delaware, Lackawanna and Western's Cayuga Colliery, shown here around 1910, processed 6,418,708 tons of anthracite from July 1870 through December 31, 1910. The colliery's best year was 1903, when 278,858 tons of anthracite passed through. The breaker had an average daily production of 630 tons and employed 134 miners, 143 laborers, 136 inside company men, and 68 outside company men in 1910.

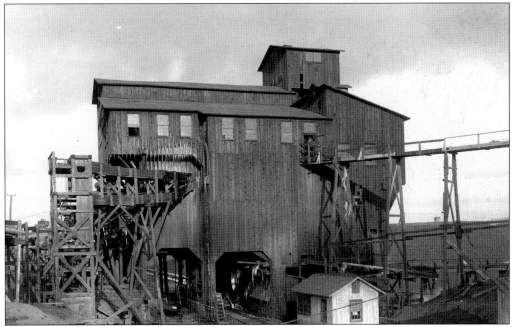

BELLEVUE COLLIERY. Between 1859 and 1910, the Bellevue Colliery, pictured around 1910, processed 10,482,796 tons of coal. Average daily production in 1910 was 1,741 tons, while the average number of employees was 1,037, including 310 miners, 310 laborers, 249 inside company men, and 168 outside company men.

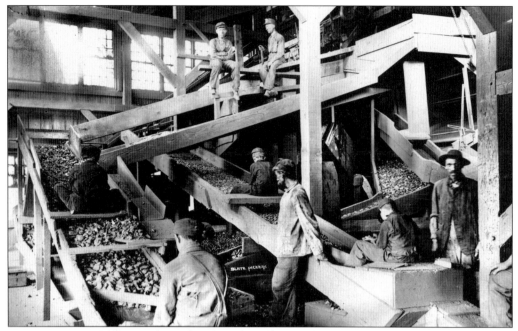

SLATE PICKERS. Collieries cleaned and sized coal before shipping it to market. During the 19th century, slate pickers, or "breaker boys," aged 10 to 18 years picked rock from the coal as it thundered down a long chute. Workers could often lose fingers doing this difficult and tedious job. After the Anthracite Coal Strike of 1902, new laws prohibited the use of child labor in this type of activity.

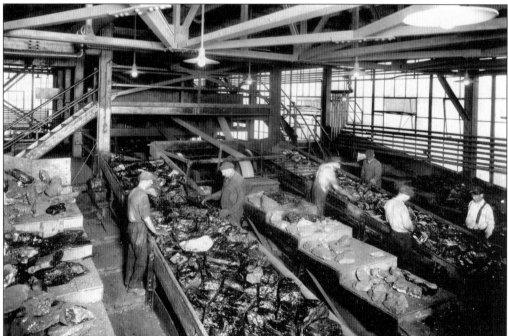

PICKING TABLE. After 1902, coal companies developed new methods to remove impurities from coal. In this photograph, men use the dry method of removing rock at a picking table inside a breaker.

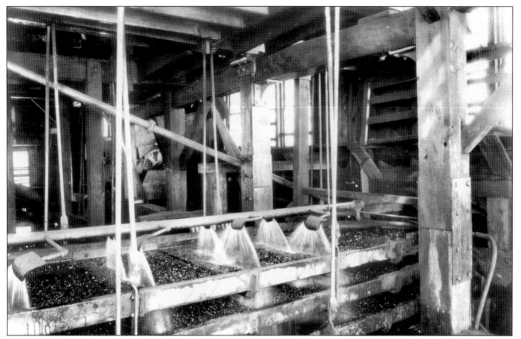

MECHANIZED COAL-WASHING PROCESS. Inside a breaker, mined coal was sized and then moved to the washery, where a rinsing process used water to remove impurities.

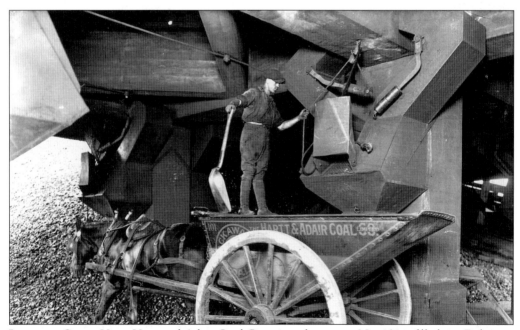

LOADING COAL. Here, Hart and Adair Coal Company dump cart No. 101 is filled at a Delaware and Hudson Coal Company breaker. The metal box that carries the coal is highly decorated, down to pin-striping on the wheels. Once the cart is full, coal will be delivered to customers.

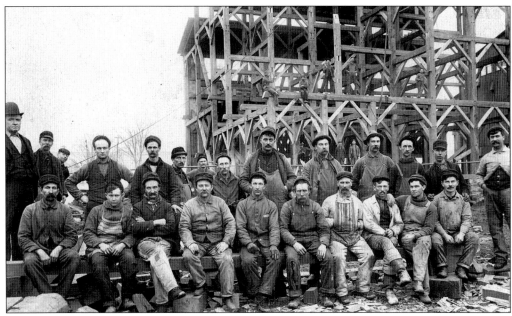

CONSTRUCTION WORKERS AT COLLIERY. During the 19th century, collieries were large wooden structures. In this 1889 photograph, construction workers pose in front of a half-completed wooden colliery frame. The worst enemy of a wooden colliery was fire. A spark from a locomotive, or arson, could mean a colliery's demise. Later, steel would be used to construct these mammoth structures.

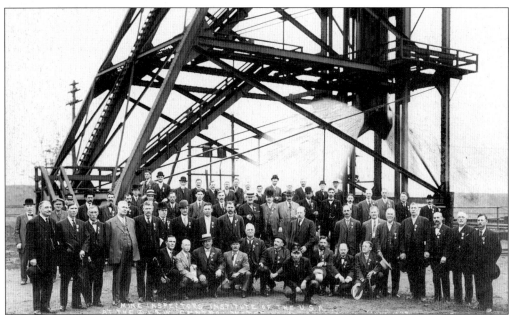

MINING INSPECTORS AT HOIST. Members of the Mine Inspectors Institute of the United States of America were photographed in 1909 near a Scranton breaker owned by the Delaware, Lackawanna and Western Railroad. The institute held annual meetings to explain new rules to mine inspectors. Here, inspectors view a water hoist with the capacity of 250,000 gallons per hour. To prevent flooding, it was imperative to pump water from underground mines.

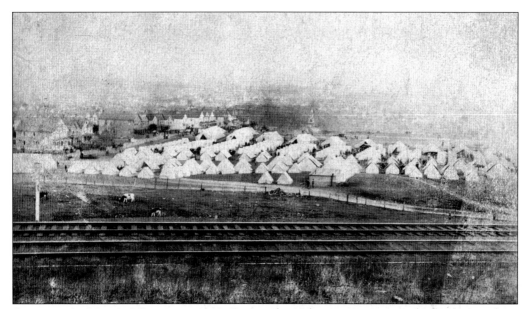

ANTHRACITE MINERS' STRIKE OF 1902. During the 19th century, impoverished miners working in unsafe conditions had called strikes at individual mines. In 1902, the United Mine Workers Union, led by John Mitchell, called a wide-scale strike. The governor of Pennsylvania sent the National Guard to Scranton to maintain order. This R. W. Jeffers photograph, taken from No. 40 School near North Sumner Avenue, depicts a National Guard encampment.

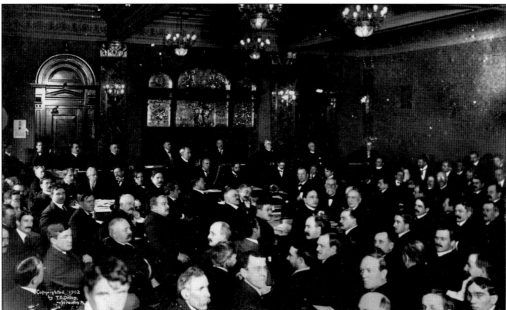

MINE STRIKE COMMISSION. In response to the strike of 1902, Pres. Theodore Roosevelt ordered the creation of a group to bring labor and capital together, marking the first involvement of the federal government in labor relations. The commission laid the foundation for all subsequent wage agreements between coal operators and mine workers. This photograph documents the meeting of the Anthracite Mine Strike Commission at the Lackawanna County Courthouse on November 17, 1902.

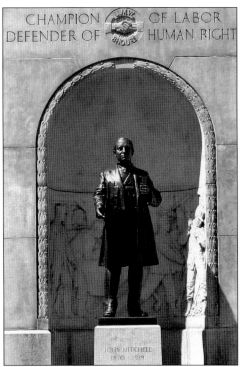

JOHN MITCHELL MONUMENT. On May 30, 1924, the United Mine Workers of America erected a monument to their popular past president John Mitchell (1870–1919) on the Lackawanna County Courthouse Square. This monument to labor features a life-size bronze figure of Mitchell by sculptor Charles Keck, set in a granite framework designed by architect Peter Sheridan. The monument and its surrounding courthouse complex were added to the National Register of Historic Places in 1997.

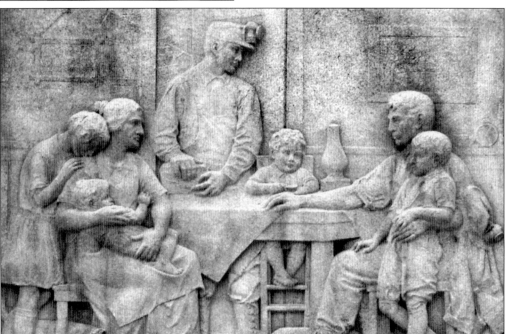

MITCHELL MONUMENT RELIEF. The reverse side of the Mitchell Monument features a carved granite relief showing a miner's family in their kitchen. In the sculpture, the father and eldest son are dressed for mining, while the younger children are clothed for school. These figures stress the post-strike change in family life after new labor regulations abolished child labor. They also symbolize the value many mining families placed on kinship, work, and education.

Three
URBAN GROWTH

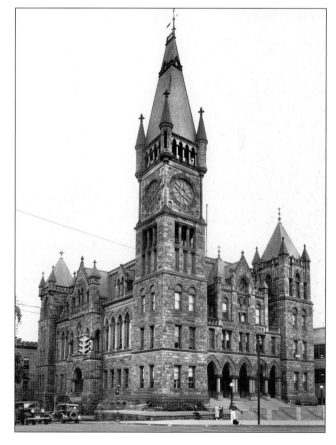

CITY HALL. Thriving industry brought prosperity, and architecture was a notable means of demonstrating community wealth. Architects Edwin L. Walter and Frederick Lord Brown, with builder Conrad Schroeder, erected city hall at the corner of Washington Avenue and Mulberry Street between 1886 and 1888. The proud Gothic structure housed city offices. It was added to the National Register of Historic Places in 1981.

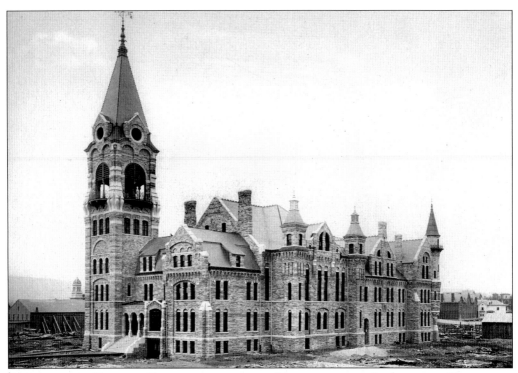

LACKAWANNA COUNTY COURTHOUSE UNDER CONSTRUCTION. Lackawanna County was incorporated in 1878. Land for a new courthouse was donated by the Lackawanna Iron and Coal Company and by trustees of the Susquehanna and Wyoming Valley Railroad and Coal Company. Valued at $100,000, the land was known as the Lily Pond. Ground was broken on April 14, 1881; crews dug an average of 30 feet to solid ground. The cornerstone was laid with an impressive ceremony.

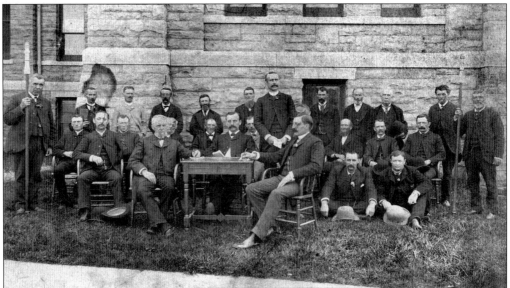

LACKAWANNA COUNTY JUDGES. Pictured here are the early judges from the Lackawanna County Courthouse.

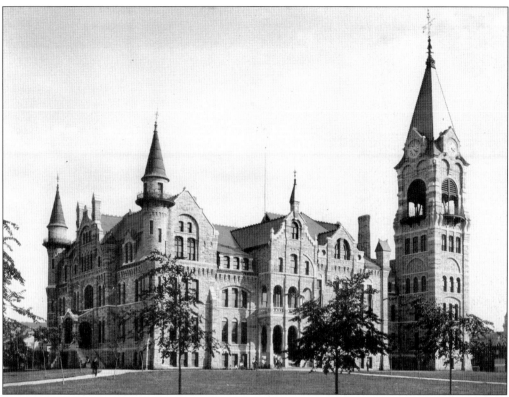

COMPLETED LACKAWANNA COUNTY COURTHOUSE. Designed by Binghamton architect I. G. Perry, this Gothic structure with Flemish details was constructed of native West Mountain stone by John Snaith, an Ithaca, New York, builder. The courthouse complex, complete with the Mitchell Monument, was added to the National Register of Historic Places in 1997.

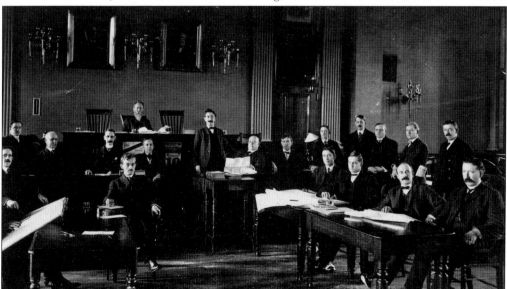

LACKAWANNA COUNTY COURTROOM. A Lackawanna County Courthouse courtroom is pictured in this photograph from November 10, 1905.

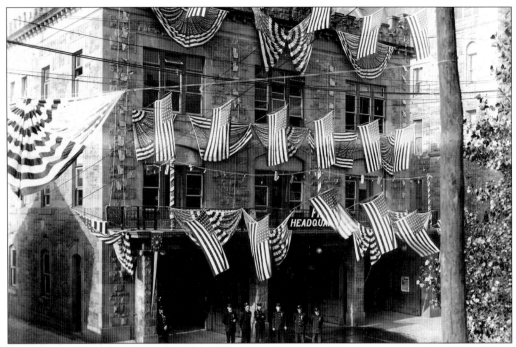

FIRE HEADQUARTERS AT CITY HALL. Fire posed a great threat to property and life. Here, Scranton's state-of-the-art fire department's main home is decked out for the country's 1916 semi-centennial.

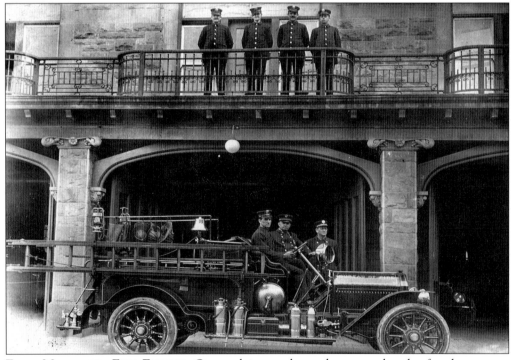

FIRST MOTORIZED FIRE ENGINE. Once relying on horse-drawn trucks, the fire department proudly displays its first motorized engine around 1915.

POLICE OFFICER DAVID H. PARRY. This early 1900s photograph depicts police sergeant David H. Parry on his beat in the wholesale district of Lackawanna Avenue. Wearing brass-buttoned frock coats and London Bobby-style helmets, patrolmen of the era carried service revolvers and nightsticks. Able to contact headquarters from telephone call boxes located along the beat, patrolmen could themselves be reached via a flashing light above the box.

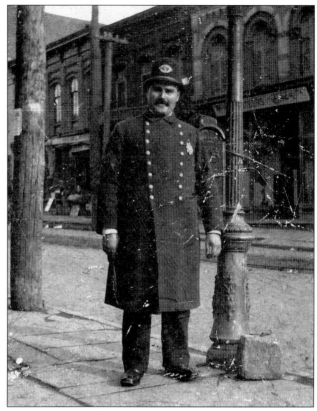

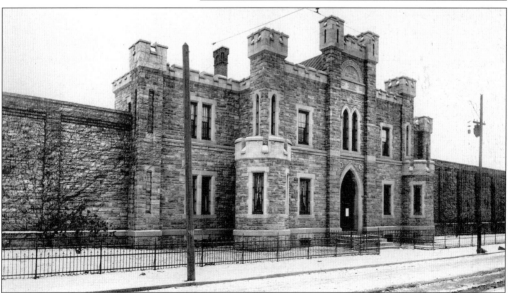

LACKAWANNA COUNTY JAIL. In 1885, county commissioners purchased land for a new jail on North Washington Avenue. B. L. Walter drew the plans, and Conrad Schroeder built it at a cost of $116,441. The prison wall extended 350 feet long, 227 feet wide, and 25 feet high. With room for 94 inmates, it opened for public inspection on December 27, 1886. The first prisoners were transported on January 3, 1887, from the original jail on Center Street.

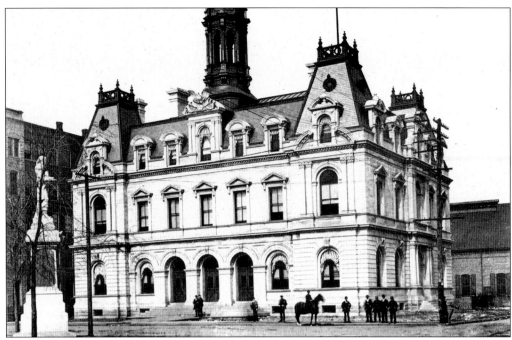

OLD POST OFFICE BUILDING. The first post office in the city was established on January 10, 1811, when the sector was known as Unionville, which then became Slocum Hollow, Lackawanna Iron Works, Harrison, Scrantonia, and finally Scranton. The first postmaster was Ben Slocum. This 1894 photograph depicts the post office at the corner of Washington Avenue and Linden Street, built that year. It was razed in 1930 for a new building, which opened in 1933.

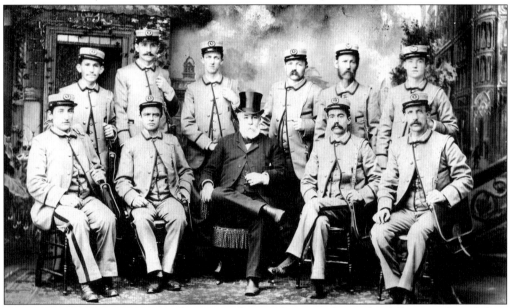

POSTMASTER AND CARRIERS. This November 1883 image shows the following, from left to right: (sitting) John Phillips, William Williams, postmaster C. E. Fuller, Harry Fuller, and E. S. Evans; (standing) Charles Kirst, Anthony Scanlon, David Jenkins, Henry Knoepfel, Samuel Heller, and Thomas O'Donnell.

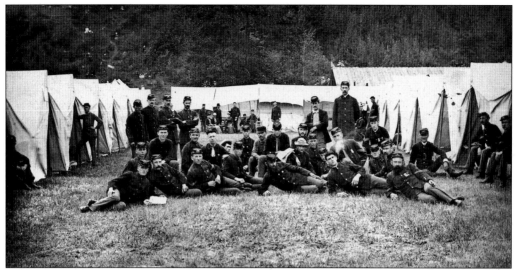

SCRANTON CITY GUARD. In response to the Strike of 1877, a permanent protective force, the Scranton City Guard, was established. Pictured is the Company D camp at Stroudsburg during the strike of 1902.

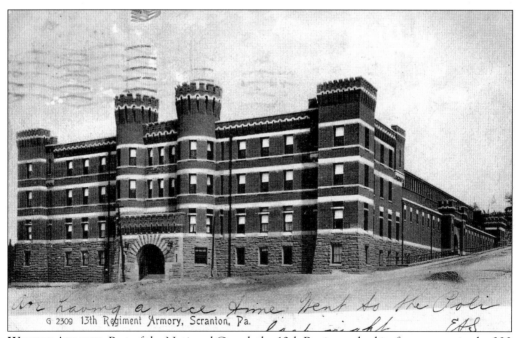

WATRES ARMORY. Part of the National Guard, the 13th Regiment had its first armory in the 300 block of Adams Avenue in 1878. The new Watres Armory, designed in the Romanesque style by Lansing C. Holden, was completed in 1901 and used for defense and arms storage. It was added to the National Register of Historic Places in 1989.

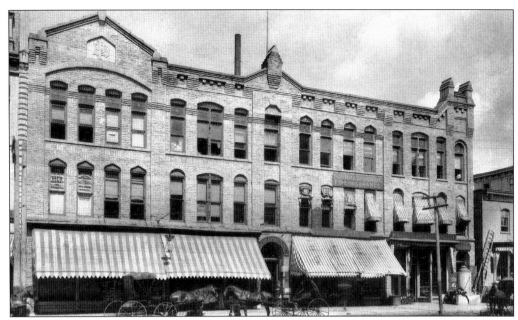

OLD LIBRARY BUILDING. In 1870, Horace B. Phelps erected the library building at 121 Wyoming Avenue. The structure was sold to Elias Morris, who then sold it to the Cleland Simpson Company in 1878. It became home to the Globe Store, a well-known dry goods business. This c. 1880 photograph shows the building after it had been enlarged by its new owners. In 1908, the new Globe Store facility was constructed on the site. It is now occupied by Diversified Information Technologies.

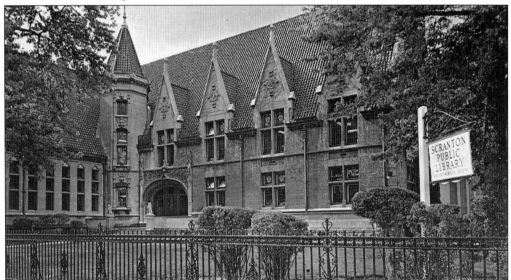

ALBRIGHT MEMORIAL LIBRARY. This jewel of French Gothic architecture was modeled after the Musee Cluny in Paris. Endowed by John Joseph Albright, this memorial to his parents was designed by Green and Wicks of Buffalo, New York, and built by Conrad Schroeder, with landscape design by Frederick Law Olmsted. Featuring a black tile Spanish roof, heavy stone, and stained-glass windows, the building cost $125,000. It was added to the National Register of Historic Places in 1978.

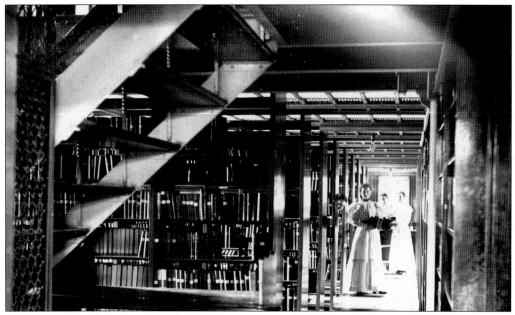

LIBRARY STACK ROOM. Albright left it up to the city to furnish the library with materials. Records of donations show gifts from prominent citizens William Smith and the Scranton family, a collection of mining-related materials, and materials obtained from other libraries. Within five years, the building housed 35,000 to 40,000 items, some of which can be seen in this July 1895 photograph.

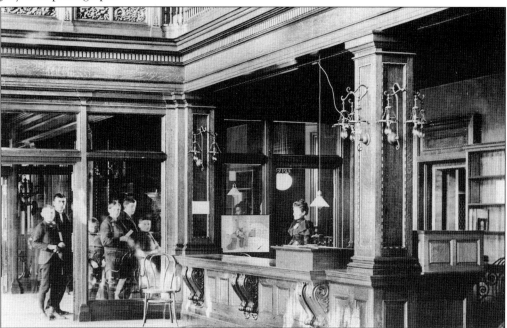

LIBRARY CIRCULATION DESK. In a January 1890 letter to the Board of Trade, John Albright expressed his wish to provide an "educational element not heretofore supplied, for the elevation of the people of all classes who may desire to avail themselves of the privileges conferred." Shown here is a librarian and patrons.

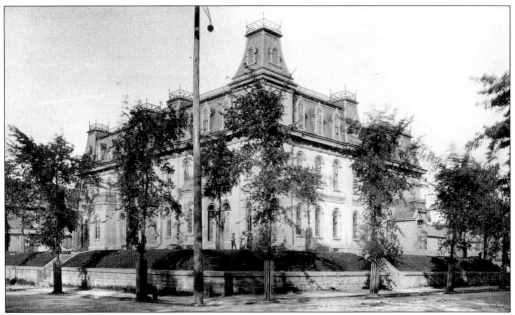

OLD SCRANTON HIGH SCHOOL. This c. 1885 photograph depicts the first high school in Scranton, designed by Joel Amsden and erected in 1858 at the corner of North Washington Avenue and Vine Street. Enlarged over the years, the school was finally deemed inadequate. It was demolished in 1894 to make way for the new Central Scranton High School.

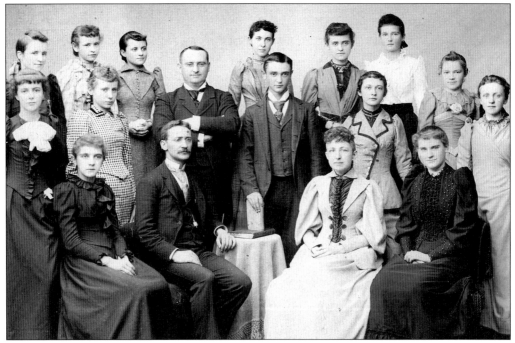

CLASS OF 1892. Identified here are Mary Jones, Mary Powell, Amy Howell, vice principal George Howell, Bertha Estelle Conger, Cora Preston, Lizzie Hall, principal J. C. Lange, Elizabeth Graham, Kitty Brown, Eliza McNally, Jessie Miller, Mary Morrow, William Schimpff, Grace Little, Eliza Chase, and Clara Niemeyer.

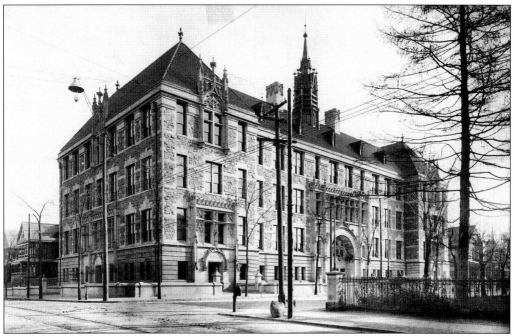

SCRANTON CENTRAL HIGH SCHOOL. This 1897 photograph shows the new Scranton Central High School, which opened in 1896 on the corner of Washington Avenue and Vine Street. The school closed in 1991.

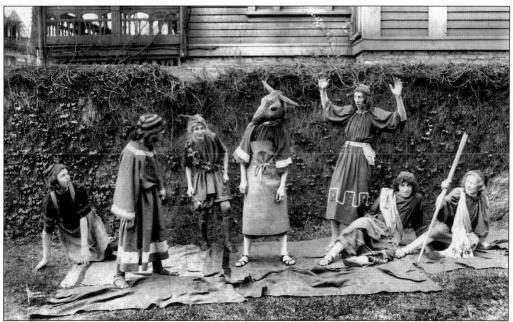

SCRANTON CENTRAL HIGH SCHOOL DRAMA GROUP. This photograph, taken in May 1914, records a performance or rehearsal of Shakespeare's *A Midsummer Night's Dream*. In this scene, Bottom appears with a donkey's head and frightens his companions. Pictured here, from left to right, are Hoyle Seeley, Harry Davis, Eugene Smiley, Harry Davis, Robert Hodgson, Morris Levine, and Eddie McHee.

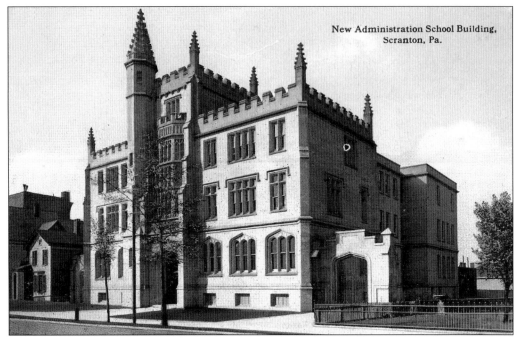

SCRANTON SCHOOL DISTRICT ADMINISTRATION BUILDING. In 1877, after the incorporation of the city of Scranton, the school districts of Hyde Park, Providence Township, Providence Borough, and Scranton Borough consolidated to form the Scranton School District. At that time, it served 4,180 students. This building still houses the offices of the school district's administrators.

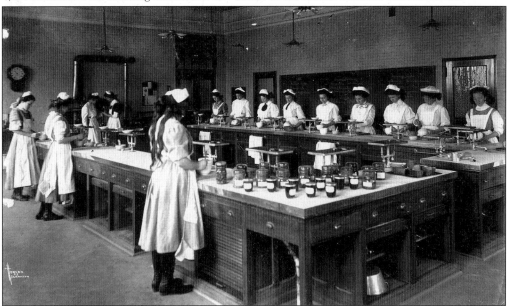

W. T. SMITH MANUAL TRAINING SCHOOL CANNING CLASS. In 1904, Mrs. W. T. Smith equipped and presented the W. T. Smith Manual Training School to the district in memory of her husband, a prominent businessman and industrialist in the 1880s and 1890s. The training center opened for the 1905–1906 school year, offering business, industrial arts, homemaking, and home economics courses, such as the canning class pictured in this Horgan photograph.

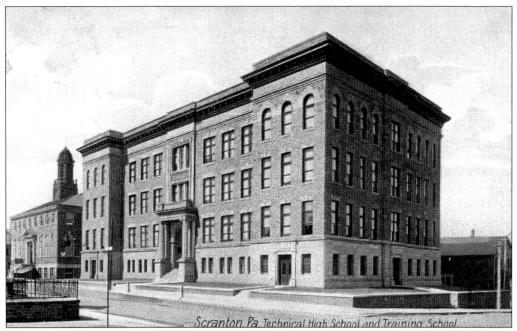

TECHNICAL HIGH SCHOOL. Scranton Technical High School was constructed at the same time as the W. T. Smith Manual Training Center, and the two were later linked by an enclosed corridor. The first class graduated from Tech in 1909.

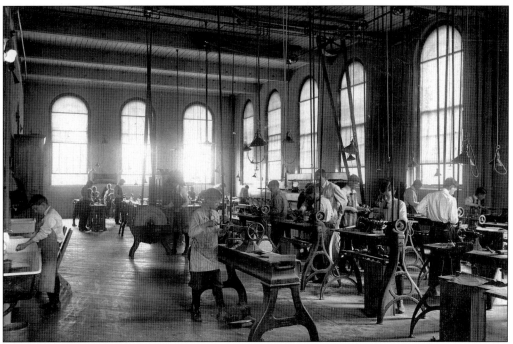

W. T. SMITH MANUAL TRAINING SCHOOL WOOD-TURNING CLASS. The W. T. Smith Manual Training School also offered courses in woodworking, depicted in this Horgan photograph, as well as printing, machinery, and later automotive and electronics.

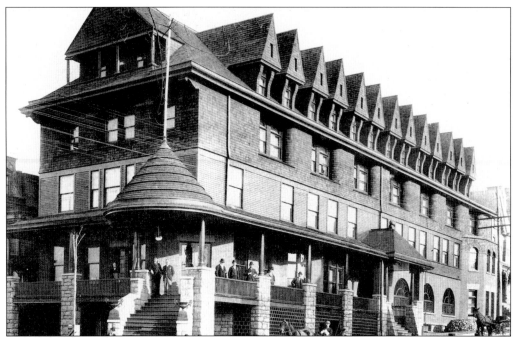

HOTEL TERRACE. Located on the corner of Wyoming Avenue and Vine Street, this four-story wood and masonry structure featured 12 gables on each side, 100 exquisitely furnished rooms, a large central hearth, heavy oaken doors, a 125-seat main dining room, private dining rooms for small parties, and a modern kitchen. W. H. Whyte was proprietor when this 1894 photograph was taken. Rates ranged from $2 to $3.50 per day.

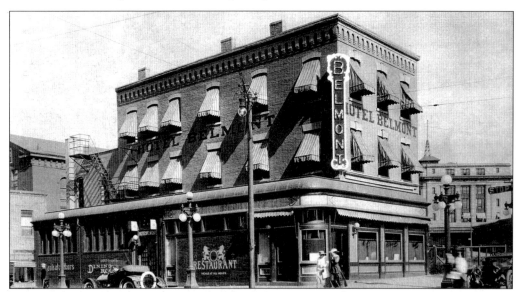

HOTEL BELMONT. Richard Kimmacher, a former porter at the Scranton House and operator of the Green Ridge Hotel, opened the Belmont Hotel at 610 Lackawanna Avenue in 1906. In 1917, Charles and Victor Wenzel became proprietors. The hotel, seen here in 1914, existed until 1946, the building later becoming Preno's Restaurant. The restaurant closed in 1999, and the structure was razed in 2000.

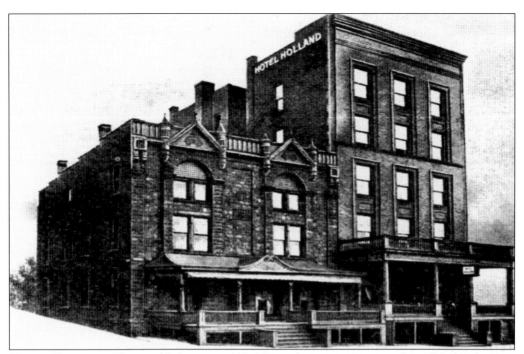

Hotel Holland. This establishment at 410 Adams Avenue was yet another of the city's many hotels. Built at the dawn of the 20th century, it was later owned by the father of actress Jean Madden Martin. Later in her life, she took ownership and oversaw operations.

Zenke's Restaurant. In 1898, Albert Zenke opened a restaurant at 213 Penn Avenue. In 1905, he moved to a larger building at 206–210 Penn Avenue, where the restaurant remained until 1955. This c. 1920 photograph shows the Alt Heidelberg and Café and Restaurant, built in the style of a timber and stucco Bavarian chalet. Business people and theatergoers enjoyed its German-American cuisine for many years.

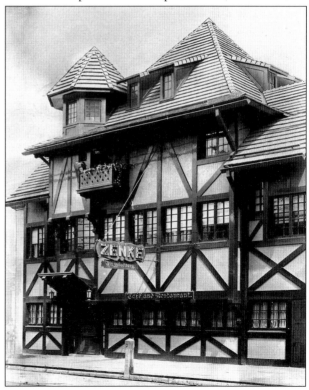

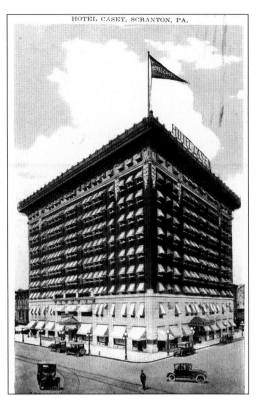

HOTEL CASEY EXTERIOR. Andrew J. and P. J. Casey established themselves as wholesale liquor distributors and brewers. Known for his business integrity, Andrew Casey served as president of both the Merchants and Mechanics Bank and the City Planning Commission. In 1910, the Caseys built a hotel on the northwest corner of Lackawanna and Adams Avenues, on the site of Col. George W. Scranton's former home. This 11-story fireproof hotel opened on January 1, 1911.

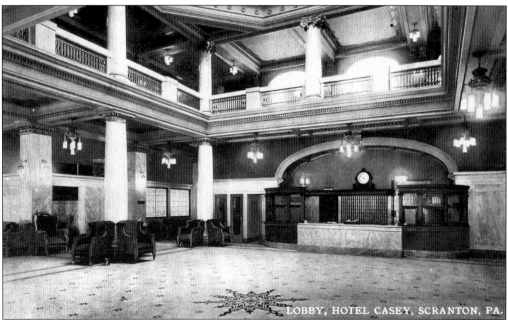

HOTEL CASEY LOBBY. Managed by Milton W. Roblee, the Casey flourished. Its sumptuous décor ranked among the best in the largest cities of the country. In his history of Scranton, Colonel Frederick Hitchcock stated, "It is a credit to the enterprise and public spirit of its owners and has undoubtedly been a booster in growth of our city."

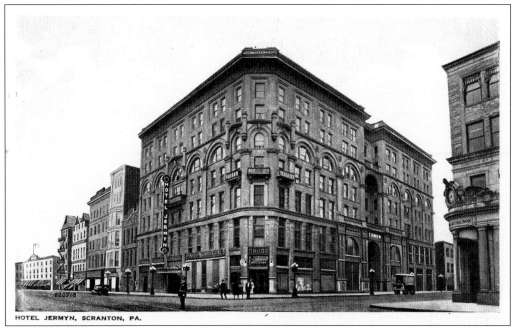

HOTEL JERMYN EXTERIOR. Designed by architect John A. Duckworth and built in 1894 by Conrad Schroeder, this elegant seven-story Romanesque building of stone and iron was a totally fireproof structure. Even the doors and furniture were originally metal. Sumptuously built and fitted, the hotel opened in 1895 under the management of Fred S. Godfrey. Some 10,000 people attended its opening.

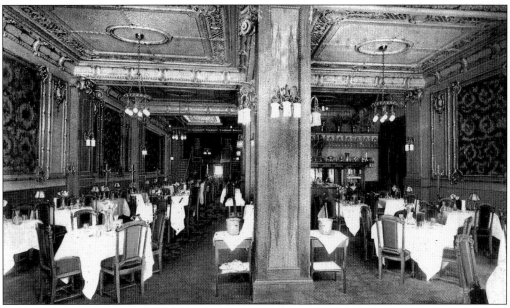

HOTEL JERMYN CAFÉ. The hotel was so successful that it was often unable to accommodate everyone who wished to stay there. Its famous Manhattan bar and its dining facilities were a favorite of prominent Scranton residents. Colonel Hitchcock called it "a great addition to the city not only in the character of the building, but in the superb service it rendered the traveling public."

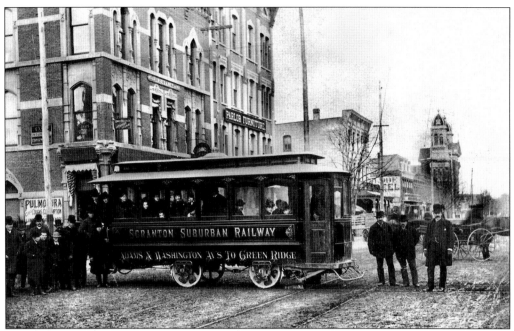

SCRANTON SUBURBAN RAILWAY TROLLEY CAR. In 1886, the Scranton Suburban Railway became the world's first commercially operated streetcar system. In this c. 1886 image, the Scranton Suburban Railway trolley car runs on Spruce Street. The trolley traveled a route along Adams and Washington Avenues to the Green Ridge section of Scranton.

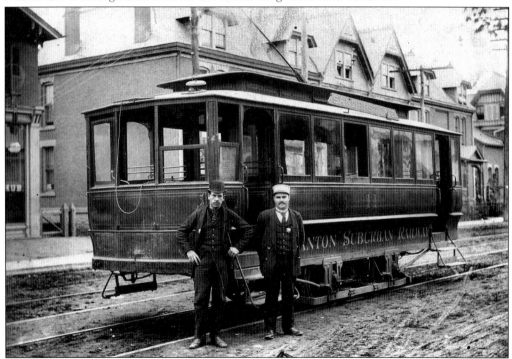

SCRANTON SUBURBAN RAILWAY TROLLEY WITH CONDUCTOR. Conductor David Parry is pictured with Scranton's first electric streetcar around 1890.

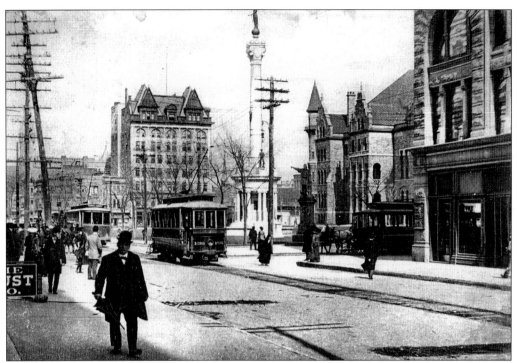

WASHINGTON AVENUE STREET SCENE. This image captures a moment of city life at the dawn of the 20th century. Trolleys and horse-drawn vehicles can be seen along North Washington Avenue and Spruce Street. Also visible are the Lackawanna County Courthouse and the Board of Trade Building. This postcard scene, marked 1905, appears courtesy of Jerry Loeffler.

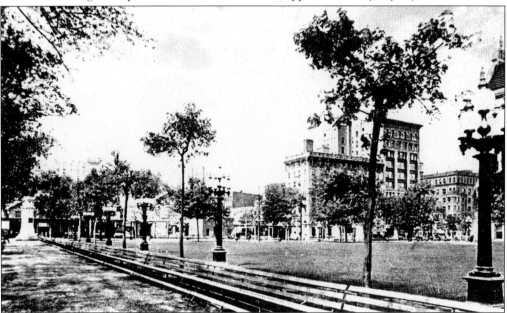

COURTHOUSE SQUARE PARK ALONG ADAMS AVENUE. This idyllic postcard photograph shows the Adams Avenue side of the Lackawanna County Courthouse Square. Also seen are the street lamps and benches encircling the square.

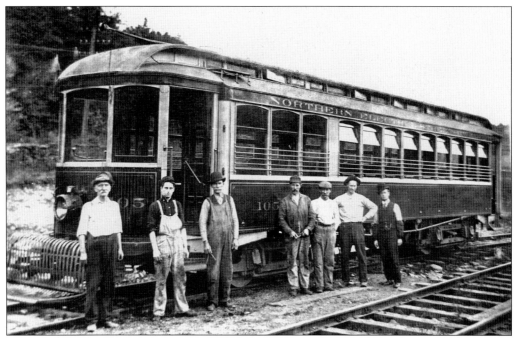

NORTHERN ELECTRIC STREET RAILWAY PASSENGER CAR. The Northern Electric Street Railway operated a line that ran from Scranton to Lake Winola and Montrose. Passenger car No. 105 is pictured here. Northern Electric ceased operations in 1932.

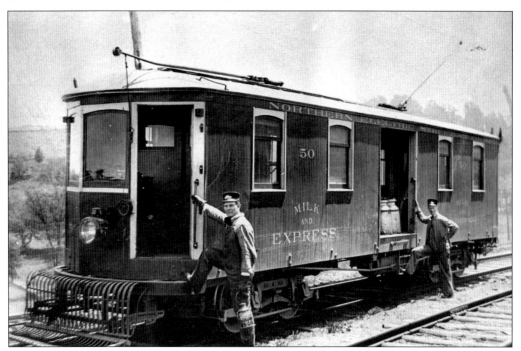

NORTHERN ELECTRIC STREET RAILWAY FREIGHT CAR. The delivery of milk and freight from Scranton to points north was a profitable part of the Northern Electric Street Railway's business. The company's milk and express car No. 50 is seen here.

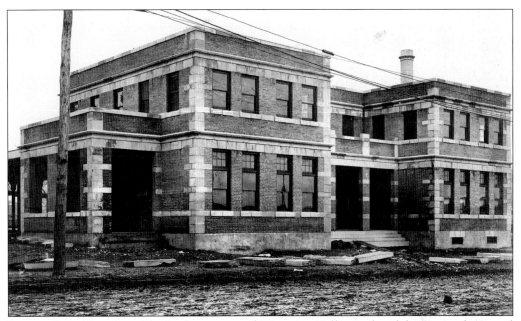

LAUREL LINE STATION. The Lackawanna and Wyoming Valley Railroad, known as the Laurel Line, provided transportation services from Scranton to Pittston, and later to Wilkes-Barre. The company's Scranton terminal, located on Cedar Avenue, housed the offices of the general manager, paymaster, engineering department, and superintendent. The building was remodeled during the 1920s.

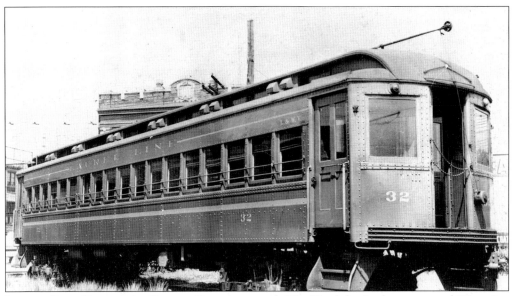

LAUREL LINE PASSENGER COACH. Passenger coach No. 32 of the Lackawanna and Wyoming Valley Railroad was made by the Osgood Bradley Car Company in 1924. Constructed of steel, the car weighed 80,000 pounds and was fitted with 64 seats. The Laurel Line ended passenger service on December 31, 1952.

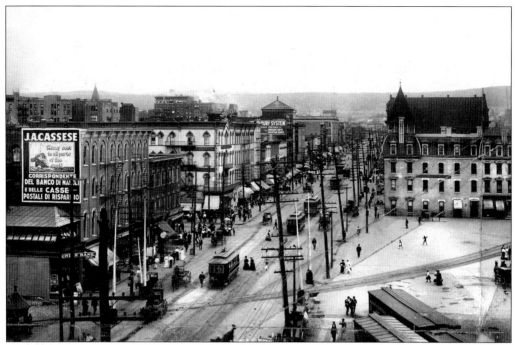

LACKAWANNA AVENUE, LOOKING EAST. This early photograph of Lackawanna Avenue shows the Scranton House on the right and the Valley House across the street from Franklin Avenue in the hub of the city's business district.

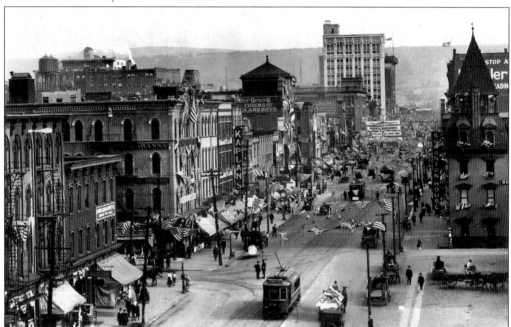

SEMI-CENTENNIAL CELEBRATION. Lackawanna Avenue, Scranton's premier street, is festively decorated for this patriotic celebration in 1916. During this period, Lackawanna Avenue was sometimes called Scranton's "Great White Way" because of the number of lights illuminating its buildings at night.

Four
BUSINESS VENTURES

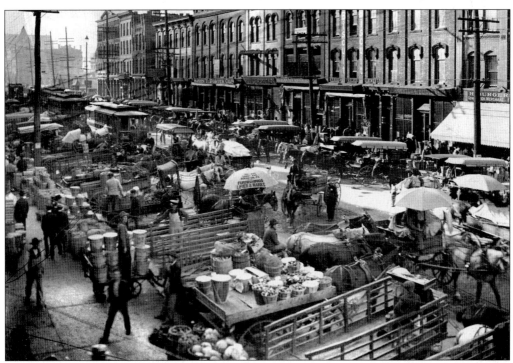

LACKAWANNA AVENUE WHOLESALE BLOCK. Since the mid-1800s, the busiest end of Lackawanna Avenue, located near the railroad, has been known as the Wholesale District. There, wagons loaded with produce, meats, and dry goods were received. Merchandise was then delivered to fill orders placed by Scranton stores, restaurants, and hotels. One of the wagons in this c. 1897 photograph is shaded by an umbrella bearing an advertisement for Lauer and Marks, established in 1851 as one of the city's oldest stores.

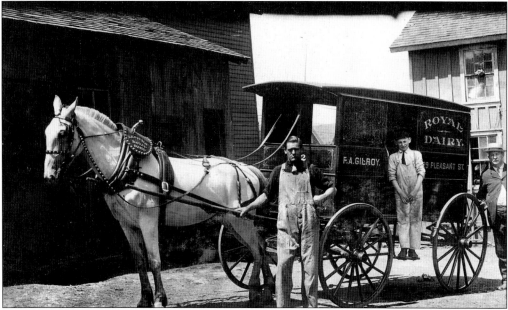

ROYAL DAIRY DELIVERY WAGON. In an era before modern refrigeration, milk, eggs, butter, and cheese were delivered to businesses and residences daily. This 1903 image depicts the delivery wagon for the Royal Dairy, owned by Frank Gilroy. Several dairies in the Scranton area provided customers with these daily staples, including Woodlawn, Burschel, and Grayce.

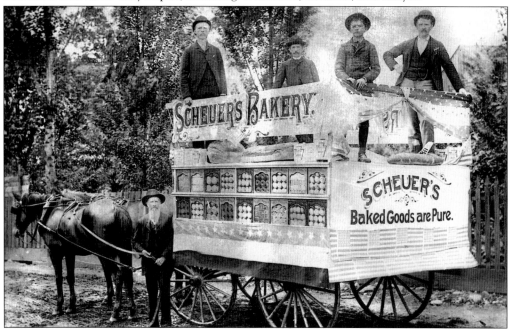

SCHEUER'S BAKERY DELIVERY CART. From left to right, John Scheuer holds the reins of the delivery wagon, along with sons John and Henry, grandson John, and son George, around 1890. A German immigrant, Scheuer came to Scranton in 1849, worked at the furnaces, and bought a wagon. In 1870, he opened a store, which moved several times. His sons took over the bakery in 1889. In its heyday, Scheuer's was the largest commercial bread bakery in northeastern Pennsylvania.

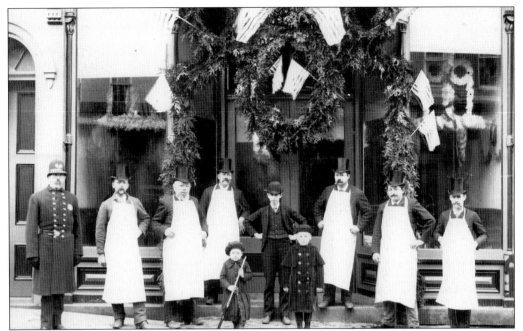

BROWN'S BUTCHER SHOP. The butcher shop was once a mainstay of household shopping, and the city had more than 100. In this 1890s photograph, Ira T. Brown's Butcher Shop at 120 North Main Avenue is decked out for the holidays, with the butchers wearing top hats instead of their traditional stiff-brimmed straw hats.

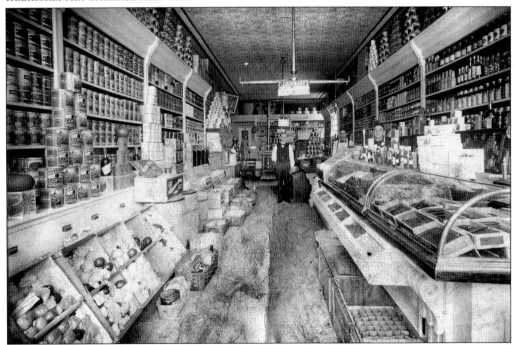

WARNKE'S STORE. In an age before widespread automobile use, every neighborhood had its own grocer. This early store, located on North Main Avenue, was typical of the many neighborhood stores in the city. Pictured here are Jacob Warnke and Gussie Morgan.

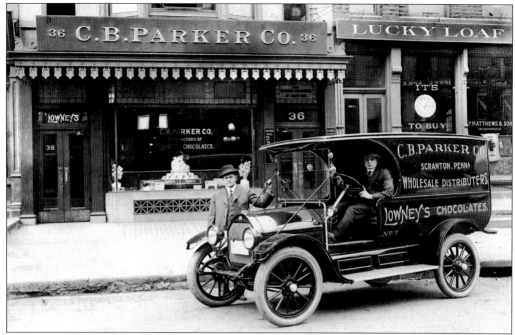

CHARLES B. PARKER COMPANY. Vibrant shops of every kind lined the streets of Scranton, offering a range of specialty goods. The Charles B. Parker Company, a wholesale distributor of Lowney's Chocolates, was located in the 300 block of Lackawanna Avenue. This photograph was taken on July 10, 1915.

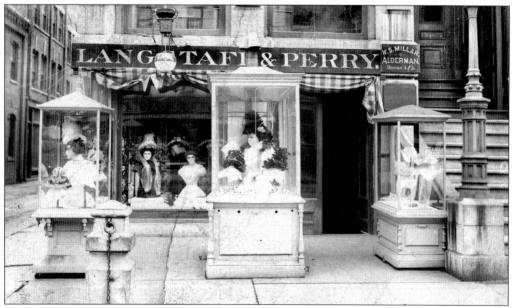

LANGSTAFF AND PERRY MILLINERY. In an age when a lady would not be seen in public without a hat, Scranton boasted more than 40 millinery shops. This 1897 image shows Langstaff and Perry at 115 Wyoming Avenue, one of the city's more fashionable millinery shops, managed from 1894 to 1899 by sisters Eva and Nellie Perry. After 1899, the sisters split to manage hat shops at other locations in the city.

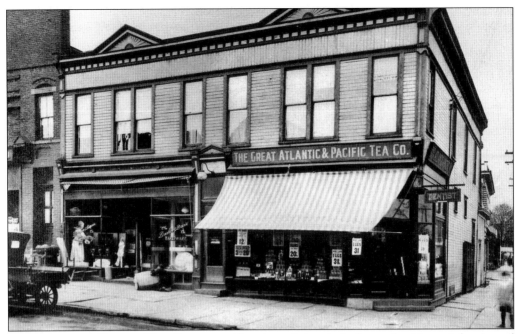

ATLANTIC AND PACIFIC TEA COMPANY. Another of the city's shops, the Great Atlantic and Pacific Tea Company offered tea, foodstuffs, and quality service to its customers. This photograph also depicts the Durkin and Davis Plumbing and Hardware. The tea company later expanded and became known as the A&P.

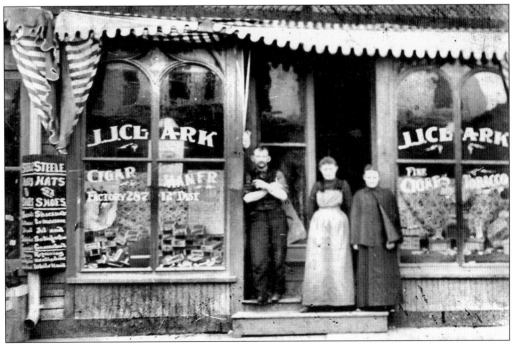

CLARK CIGAR MANUFACTURER. Scranton was once home to more than 20 cigar factories. Jacob D. Clark Cigar Manufacturer, located at 135 Penn Avenue, was listed in city directories between 1879 and 1897. In 1901, the business relocated to a store at 313 Spruce Street, shown here.

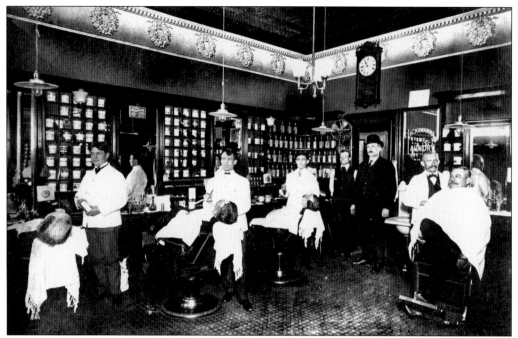

BARBERSHOP INTERIOR. This c. 1900 photograph depicts the interior of the Scranton House barbershop, located at 206–210 Lackawanna Avenue. Pictured from left to right are Doc DeOruino, barber; Mike Sullivan; Louis Dernin, head waiter at the Scranton House hotel; George Kock, son of the owner; Mr. Mercer, a cigar salesman for Bella Cara Cigars; Joseph Speicher, barbershop owner; and John Kaufman, bartender at the Scranton House.

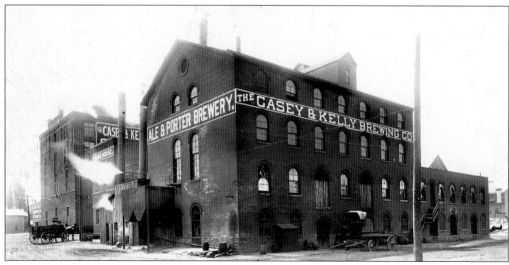

CASEY AND KELLY BREWERY. Brewing was a thriving practice in the city, with E. Robinson's Sons Brewery, located at Seventh Avenue and West Linden Street, boasting the first refrigeration plant on the East Coast. Later, Patrick F. Cusick and a Robinson son opened the Standard Brewing Company. This photograph shows the Casey and Kelly Brewery at its Remington Avenue and Locust Street site.

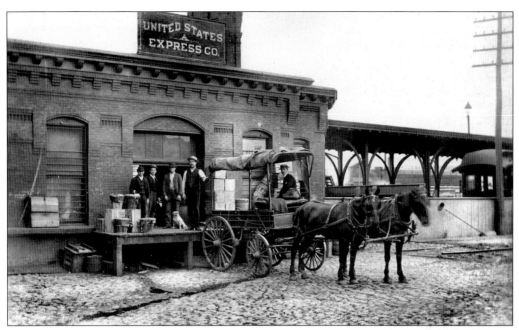

UNITED STATES EXPRESS COMPANY. As an economic center, Scranton needed efficient shipping agents. The railroads handled larger shipments, and companies such as the United States Express Company, at 328 Lackawanna Avenue, handled both packages and freight. With F. D. McGowan as agent, the company was a predecessor of the Railway Express Company. It is pictured here in the early 1900s.

LACKAWANNA STEAM LAUNDRY. Local water was free of lime and other harmful substances, allowing the city's laundry industry to thrive. In 1886, Andrew B. Warman of New Jersey opened a small business at 231 Wyoming Avenue. The business expanded, and he purchased property at 308–312 Penn Avenue and erected the building shown here. The laundry's innovative process included a filtration system that ensured uniform cleanliness. Clients included leading hotels, families, and individuals.

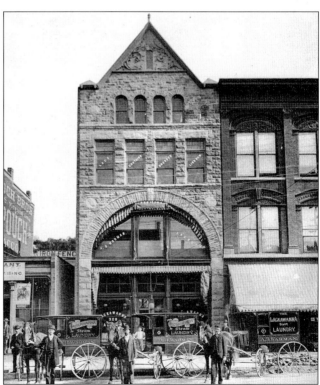

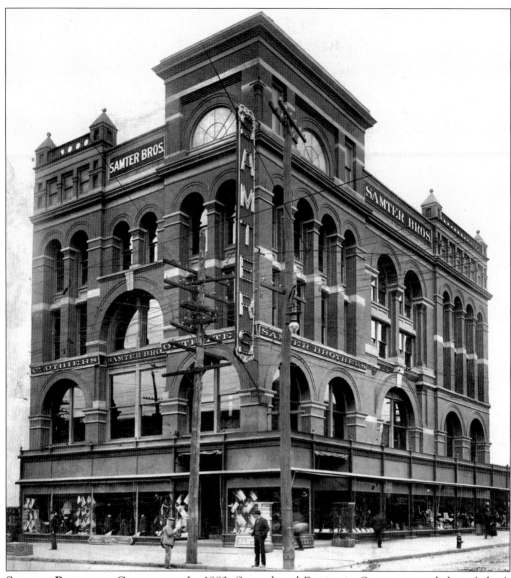

SAMTER BROTHERS CLOTHIERS. In 1883, Samuel and Benjamin Samter moved their father's business to Lackawanna and Penn Avenues. The building, known as Washington Hall, was owned by F. S. Pauli. The store sold men's suits and coats from one room. In 1888, Samter Brothers razed it and erected the building pictured here. An upper floor housed Woods Business College. The store's Penn Avenue neighbors included St. Charles Hotel, Mackey and Benney's wines and liquors, and several hotels.

Samter Bros., Co.
ESTABLISHED 1872

· SCRANTON · PA ·

Dear Rensselaer,

Well, Well, Well — six years old! You'll soon be a great big man and wear long pants like Daddy does.

Many happy returns of the day, old fellow — and if you're as good all next year as you have been this year, you'll hear from us again — then.

Here's your birthday gift from Samters. We never forget good boys, so be a good boy always and you won't be sorry.

 Yours very truly,
 Samter Bros. Co.

LETTER TO A YOUNG PATRON. Known for its quality merchandise and personal service, Samter's became a city institution. This Samter Brothers letter was received by Rensselaer P. Norton Jr. on the occasion of his sixth birthday, on January 3, 1939.

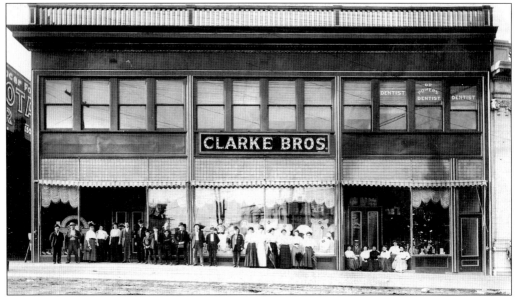

CLARKE BROTHERS STORE. Shortly after 1842, Oliver P. Clarke and William Blackman became partners, with a store located at the corner of Luzerne Street and Main Avenue on Scranton's west side. Later, Clarke took sole proprietorship and moved to Main Avenue and Jackson Street. Matthew Clarke followed into the business, establishing a location at 322 North Main Avenue.

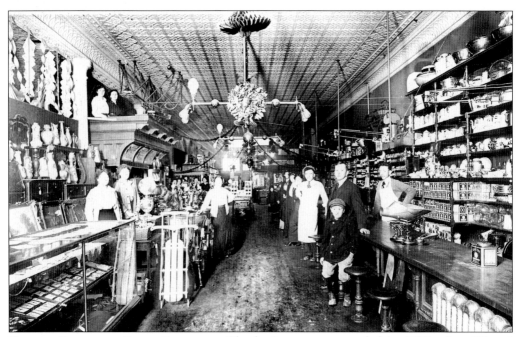

CLARKE BROTHERS STORE INTERIOR. The business was expanded in 1888, when Edward Clarke assumed ownership. In 1893, Edward's brother George joined the business. By the end of the century, the original store occupied 310–322 North Main Avenue, and the Clarke brothers were operating nearly 20 stores at various locations in Scranton and the surrounding area.

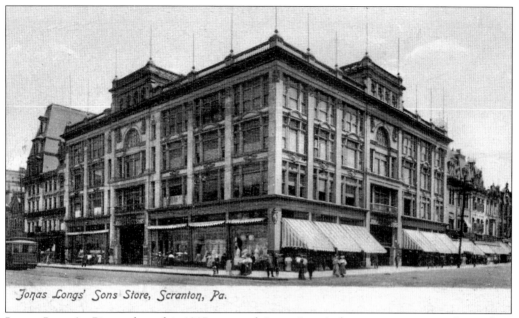

JONAS LONG'S. Pictured on this 1907 postcard, Jonas Long's department store was located on the corner of Lackawanna and Wyoming Avenues beginning around 1898. It was purchased by Scranton Dry Goods in 1917 and later renamed Oppenheim's.

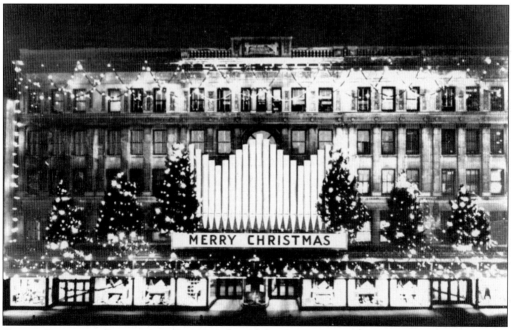

GLOBE STORE AT CHRISTMAS. In 1878, the Globe Store, founded by John Cleland and John Simpson, opened in a four-story building on Wyoming Avenue. In an era of barter and made-to-order merchandise, the Globe, as an early department store, offered ready-made retail goods at fixed prices. Shopping at the Globe, seen in the early 1940s, became a Scranton tradition. (Courtesy of Diversified Information Technologies.)

SCRANTON TRUTH BUILDING. The *Scranton Truth* was published daily from 1884 until 1915, with John E. Barrett and James J. Jordan as owners and publishers. Originally located in the building owned by F. S. Pauli at the corner of Lackawanna and Penn Avenues, the *Scranton Truth* later moved to 400–402 Penn Avenue, the location shown here.

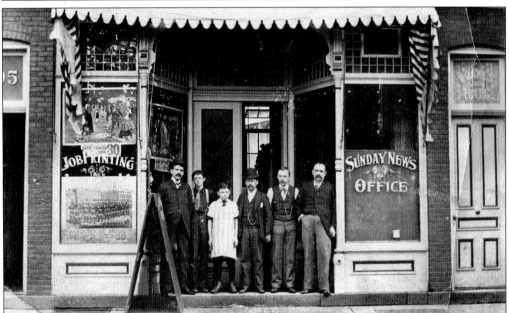

SUNDAY NEWS BUILDING. Established by J. C. Coons, formerly of Free Press Publication, the *Sunday News* was located at 207 Spruce Street, with Frank B. Woodward as editor. The paper was later owned by Col. F. J. Fitzsimmons, then, upon his death, his brother John, and finally a Mr. Little. The newspaper closed in 1903. Here, the window displays an advertisement for the Academy of Music, around 1895. The site is now occupied by PNC Bank's drive-through windows.

OLD SCRANTON TIMES BUILDING. The *Scranton Times* opened on October 10, 1895, in offices on Oakford Court at the rear of the Hotel Jermyn. E. J. Lynett, its first editor and publisher, eventually purchased the newspaper. In 1901, the paper moved to 220 Spruce Street, and the property was expanded. Later, the adjoining lot was purchased, and the building pictured here was erected at 220–224 Spruce Street. It opened with a celebration on October 10, 1906.

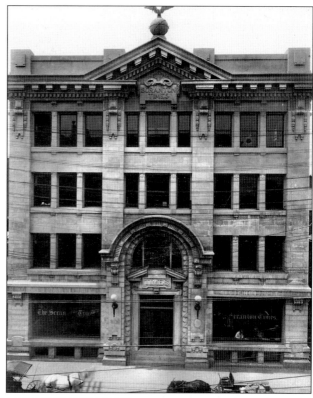

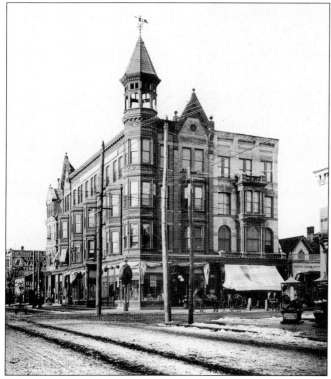

TRIBUNE BUILDING. The first issue of the *Scranton Tribune* appeared on June 20, 1891. At first only four pages, the newspaper devoted a section to the progress of local industries. To supplement the often raw news of the day, the paper included quality fiction and poetry. Located at 225 Spruce Street, the paper's building was also home to Tribune Publishing, with E. P. Kingsbury as president and general manager and W. W. Davis as superintendent.

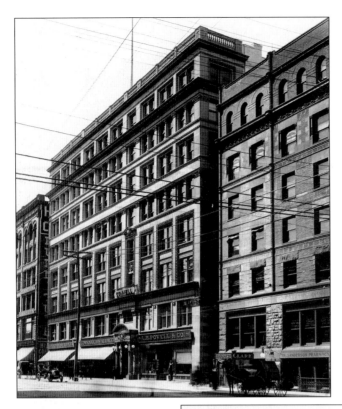

CONNELL BUILDING. Located at 129 Washington Avenue, this office building was designed by Lansing C. Holden and erected in 1894 by Conrad Schroeder. Originally only 40 feet wide, additions were built in 1901. It contained the offices of companies from Arizona, Colorado, New York, and other states.

SCRANTON REPUBLICAN BUILDING. The Scranton Directory of 1890 lists this building, also built by Conrad Schroeder, as housing a book-binding and book-manufacturing company. Owned by Joseph A. Scranton, the building also held the offices of the Babylon Coal Company, with capital of $100,000.

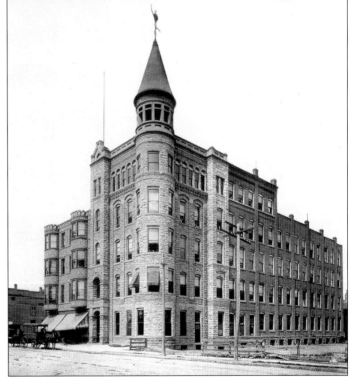

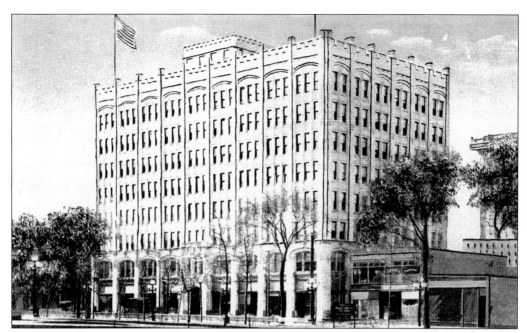

SCRANTON LIFE BUILDING. This eight-story building was designed in the Chicago style by Scranton architect Edward Langley and constructed in 1916 for the Scranton Life Insurance Company. Located near the corner of Spruce Street and Adams Avenue, the building features Gothic details and symbolic carvings, including eagles to represent protection and strength.

COAL EXCHANGE BUILDING. Erected by John Jermyn in 1885, the Coal Exchange Building, located at 124 Wyoming Avenue, is pictured around 1902. Designed by local architect John Duckworth and built by Conrad Schroeder, it was one of Scranton's first office buildings. Jermyn owned several businesses, and the town of Rushdale was renamed Jermyn in honor of his community improvements. The building was razed in 1962. Today, the Wachovia Bank occupies its former location.

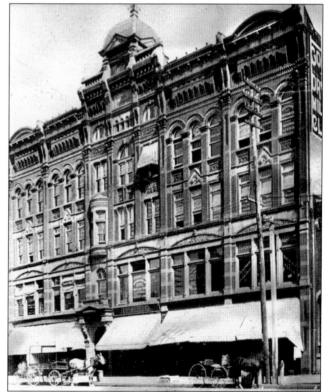

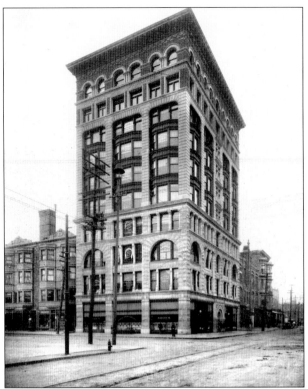

MEARS BUILDING. This 10-story office building at 144 North Washington Avenue was designed by Isaac L. Williams in 1896. It reflects the Richardsonian Romanesque style and features monumental round stone arches. Shown around 1897, the Mears Building housed many businesses, including the People's Bank.

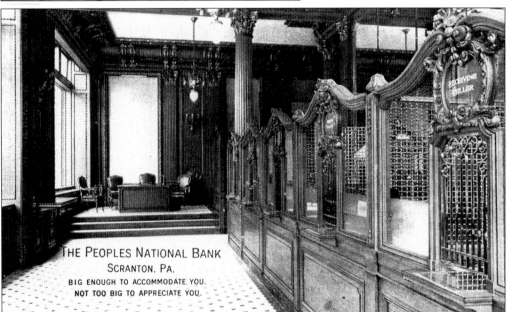

PEOPLE'S BANK INTERIOR. Organized in December 1900, the People's Bank opened on May 1, 1901, in the Mears Building. The bank grew rapidly, and in 1906, it purchased the Commonwealth Building on the corner of Washington Avenue and Spruce Street. This postcard reads, "Big enough to accommodate you. Not too big to appreciate you." It shows the opulence common to Scranton buildings at the time.

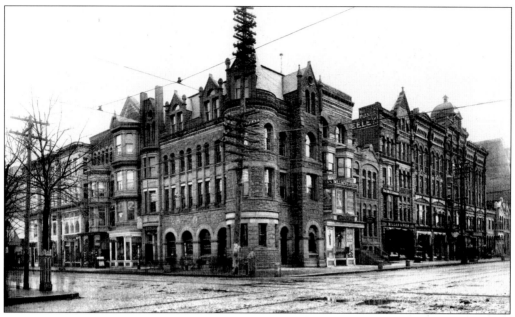

DIME BANK EXTERIOR. The Dime Bank was incorporated in 1890 with a capital stock of $100,000. Charles Schlager proposed to erect a building on the corner of Spruce and Wyoming, on the site of the Silkman home, and the resulting Romanesque structure was ready for occupancy in March 1891. The bank opened on March 30, 1891, with James P. Dickson as the first president and H. G. Dunham as the first cashier.

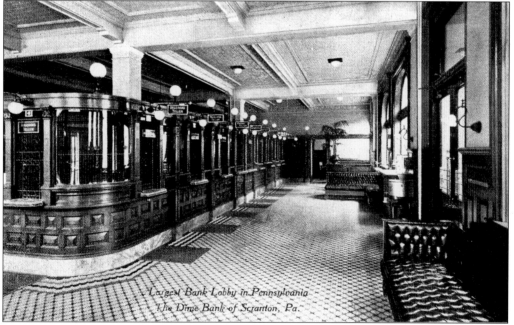

DIME BANK INTERIOR. Mary E. Conwell made the first Dime Bank deposit in the amount of $5. This postcard shows the exquisite interior of what was then the largest bank lobby in Pennsylvania. The building was added to the National Register of Historic Places in 1978.

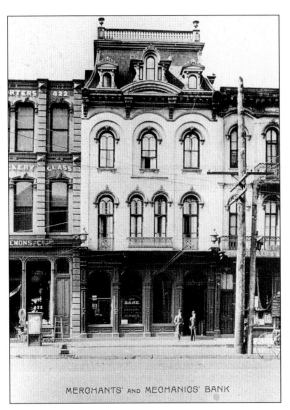

MERCHANTS AND MECHANICS BANK. This *c.* 1894 photograph shows the original Merchants and Mechanics Bank building at 420 Lackawanna Avenue, later leveled by a gas explosion. Owned by Judge John Handly, the bank was organized and chartered under the state banking laws of 1869. Andrew Casey served as its president for a time. The new bank building, with its striking dome, was designed by architect Robert W. Gibson and later became the Strand Theater.

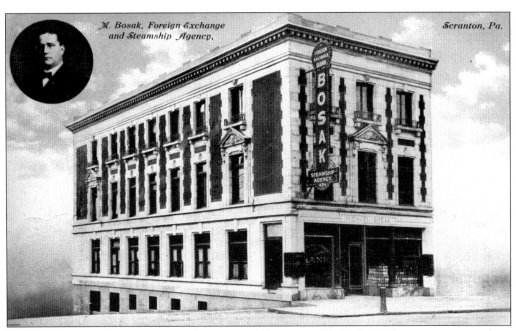

BOSAK FOREIGN EXCHANGE AND STEAMSHIP COMPANY. Michael Bosak, an immigrant from Slovakia, took over the former First National Bank of Scranton building at the corner of Lackawanna and North Washington Avenues. There, he opened the foreign exchange bank in 1907.

UNION NATIONAL BANK. This postcard dates from 1907, the year Union National Bank opened at 420 Lackawanna Avenue. In 1915, it moved to a 12-story office on North Washington and Lackawanna Avenues. In 1933, the banks were closed by President Roosevelt, and the Union Bank later reopened as the Scranton National Bank.

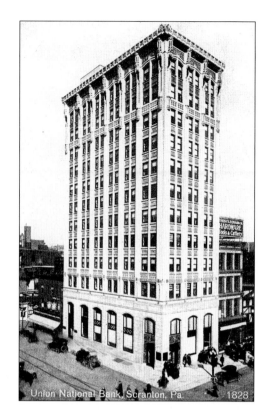

FIRST NATIONAL BANK. Established on May 30, 1863, in accordance with the Chase National Banking Act, First National started with capital of $200,000, a difficult sum to raise in the war years. It occupied a three-story building on Lackawanna and Wyoming Avenues for almost 40 years. This new structure was built at Washington Avenue and Spruce Street. Originally four stories, the building has had several additions. This postcard shows the bank as it looked in 1935.

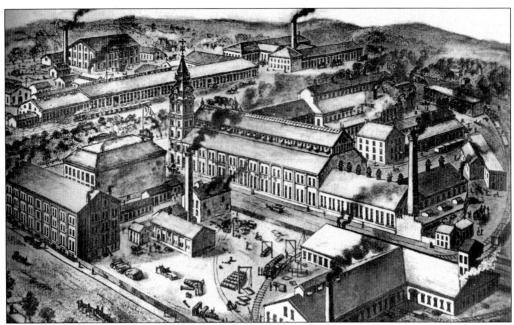

DICKSON MANUFACTURING COMPANY. Thomas Dickson started as a mule driver with the Delaware and Hudson Railroad. In 1855, he founded Dickson and Company with John and George Dickson and other partners. Incorporated in 1862, the company was divided into departments for artists, designers, draftsmen, other engineers, and tool and pattern makers and shops for construction, machines, foundries, boilers, and woodworking.

THE DICKSON MANUFACTURING COMPANY

SCRANTON, PA. WILKES-BARRE, PA.

BUILDERS OF

LOCOMOTIVES

FOR EVERY KIND OF SERVICE,

CABLE MACHINERY,

AND ALL KINDS OF

STATIONARY ENGINES,

Including the Dickson Corliss, Van Vleck Triple and Quadruple Expansion, Blast Furnace, Hoisting and Pumping Engines,

Also COAL MINING MACHINERY AND BOILERS OF ALL DESCRIPTIONS.

GENERAL OFFICE, SCRANTON, PA.

DICKSON ADVERTISEMENT. The company manufactured stationary engines, blast furnaces, locomotives, boilers, and mining, rolling mill, steelworks, and waterworks machinery, among other items. This undated advertisement shows James P. Dickson as president.

RAW SILK SAMPLE AND JAPANESE LABEL. Silk manufacturing became a leading local industry in the 1870s. Abundant land, ample water, an excellent supply of electricity, and a large labor force among the miners' wives and children attracted the industry. The Harvey and Sauquoit Mills were among the leading silk mills in Scranton. Pictured here, according to the label, is "filature raw silk, the best of Japan, reeled from carefully selected cocoon Husanagisha."

LACE EMPLOYEES WITH CURTAIN SAMPLES. English lace makers came to Scranton for its cheap power and abundant labor. Established in 1897, Scranton Lace was the world's largest producer of the much-desired Nottingham Lace. In the early 20th century, it employed 1,400 workers in 28 buildings. Prior to World War II, the company was one of 10 mills in Pennsylvania that, together, produced over half of all lace goods in the country.

SCRANTON CITY RESERVOIR. Founded by Joseph Hand Scranton in 1854, the Scranton Gas and Water Company first took its water from the Lackawanna River. Water was stored in the Scranton City Reservoir and piped to center city. The reservoir, located on the corner of Madison Avenue and Olive Street, is shown here around 1875. The site is now occupied by the Covenant Presbyterian Church.

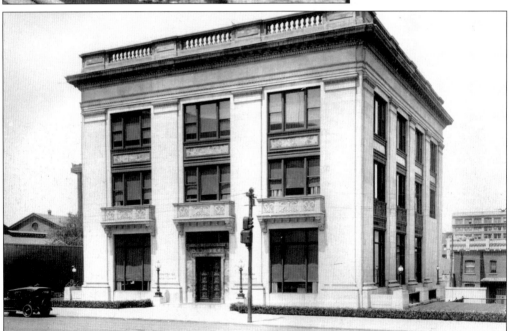

SCRANTON GAS AND WATER BUILDING. By 1858, the Scranton Gas and Water Company was supplying its customers with gas as well as water. Built in 1921–1922 in the 100 block of Jefferson Avenue, opposite the railroad passenger station, this Beaux Arts building, designed by Lewis and Davis, featured ornamental carvings of fish and dragons, symbolizing the company's products.

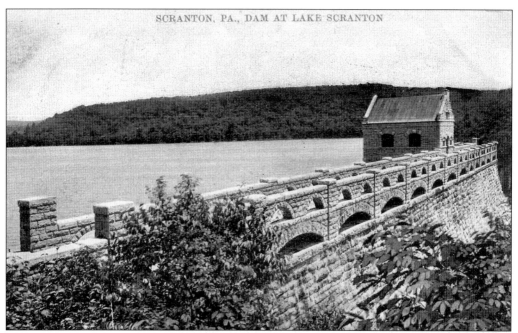

DAM AT LAKE SCRANTON. When William Walker Scranton completed the dam on Stafford Meadow Brook in 1898, he named it the Burned Bridge Reservoir, but the public called it simply Lake Scranton. The largest reservoir in the entire water system, it had a capacity of two and a half billion gallons. This postcard dates to 1908.

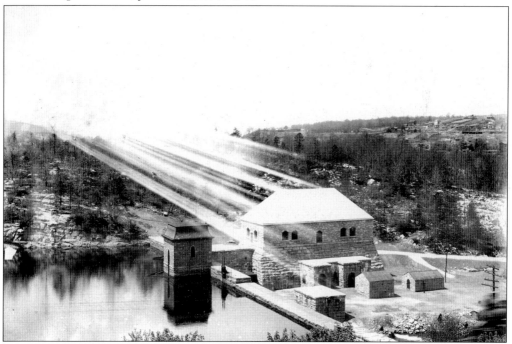

SCRANTON GAS AND WATER DAM NO. 7. W. W. Scranton provided a surface road around the lake and opened it to the public. The pavilion at the lake's north end gave a beautiful view of the water and its shore. This 1910 photograph shows a different view of the same dam.

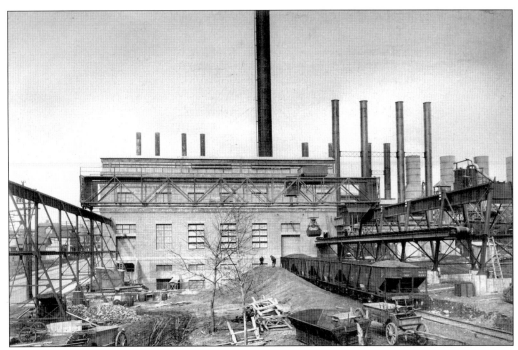

SCRANTON ELECTRIC COMPANY. W. W. Scranton established the Scranton Electric Light and Heat Company in 1883 and built the first electric plant along the Lackawanna River in 1886. In 1900, the company became the Scranton Electric Company, and in 1907, American Gas and Electric.

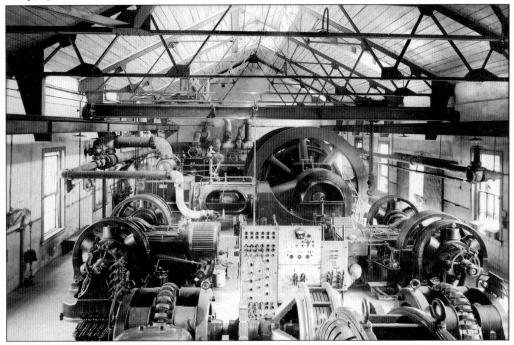

ELECTRIC COMPANY POWER PLANT. In 1880, the Dickson Manufacturing Company became an early customer for the power company's electricity. The steel mills followed in 1881, and the trolleys in 1886.

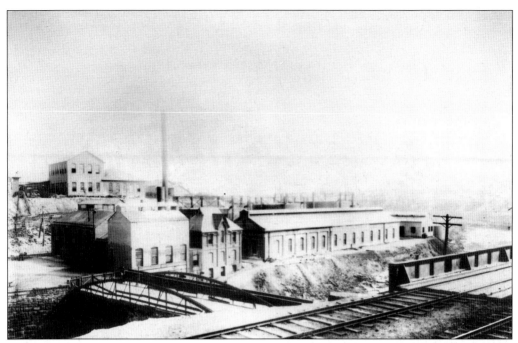

SCRANTON GAS WORKS. Even before electricity, Scranton homes and streets relied on gas for lighting. The company pictured here supplied gas for community use.

GAS STREET LAMPS. These charming fixtures along the 300 block of Adams Avenue were illuminated using gas. Pictured at the far right is Town Hall, an amusement center that opened in 1910 at 313–319 Adams Avenue. It housed a roller-skating rink and space for other popular entertainments including boxing, wrestling, music, and dancing. The building was razed in 1970, and the Geneva House now occupies the site.

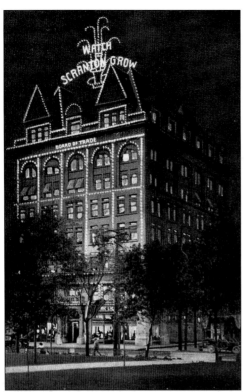

WATCH SCRANTON GROW. With the closing of the Lackawanna Iron and Steel Company in 1902, the city's economy suffered a severe blow. In 1912, the Scranton Board of Trade raised $100,000, by subscription from its members, to bring in new industries. To promote this initiative, known as the Scranton Plan, the message on the Board of Trade Building's illuminated sign was changed to "Watch Scranton Grow."

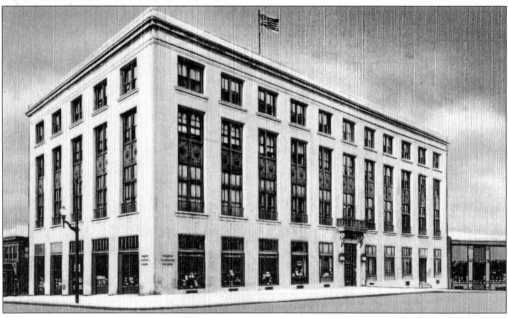

NEW CHAMBER OF COMMERCE BUILDING. In 1923, the Scranton Board of Trade changed its name to the Chamber of Commerce to reflect broadening business concerns. Work on the organization's new headquarters, located at Washington Avenue and Mulberry Street, was begun in 1925. The building, which featured an auditorium on the first floor and offices and civic quarters on the second, opened in 1926.

Five

COMMUNITY LIFE

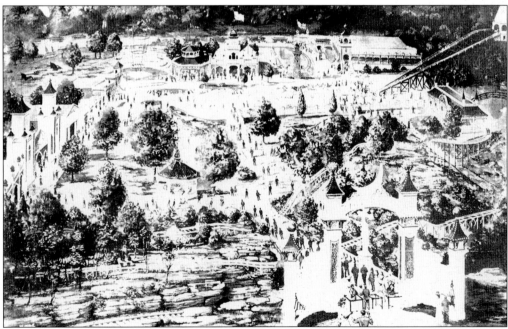

LUNA PARK. Built by Pittsburgh's Frederick Ingersoll in 1906 at a cost of $300,000, Luna Park is a fine example of the period's elaborate exposition parks, with grand buildings, ballrooms, and a restaurant; a carousel, aerial swing, and Shoot-the-Chute; a Temple of Mystery, scenic river tour, circus platform, bandstand, photography studio, and more. A fire on August 23, 1916, destroyed large portions of the park, and it never recovered from the tragedy.

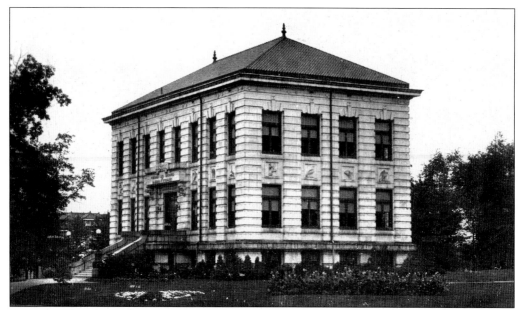

EVERHART MUSEUM PRIOR TO RENOVATION. Born in Berks County, Isaiah Everhart entered the Union Army as a medical officer and came to Scranton in 1868, where he worked as a physician and surgeon for many years. He opened the Everhart Museum on May 30, 1908, to house his extensive natural history collection. Intended as one of three buildings for arts, sciences, and natural history, the structure shown here was expanded with two large wings in 1928.

LAKE LINCOLN. On July 4, 1909, Nay Aug Park's Lake Lincoln was dedicated as the country's largest swimming pool. Retaining walls at the southern and western end created the pool, and the eastern side was enclosed by the sloping rock shelf that was part of the original land, donated by the Lackawanna Iron and Coal Company. With two and a half million tons of water, the lake was an ideal spot for summer swimming and winter skating.

THROOP MEMORIAL FOUNTAIN. Whimsical fountains like this were popular and practical in the early 1900s. Named for Dr. Benjamin Throop, this fountain provided a source of clean drinking water when tin cups were hooked to its edge. Here, children enjoy a cool drink in 1905. The fountain was a gift of John Jermyn in 1903; it was dismantled in 1933.

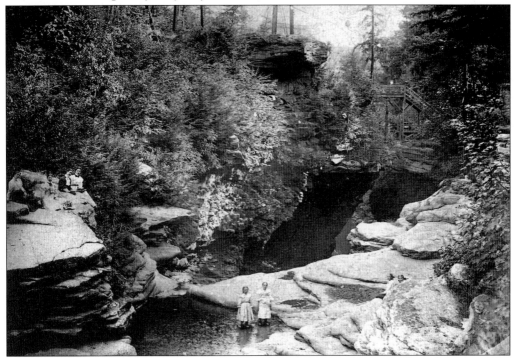

CHILDREN WADING IN ROARING BROOK. Visitors to Nay Aug Park often frequented the shaded hollows of Roaring Brook, known for its scenic waterfalls and gorge.

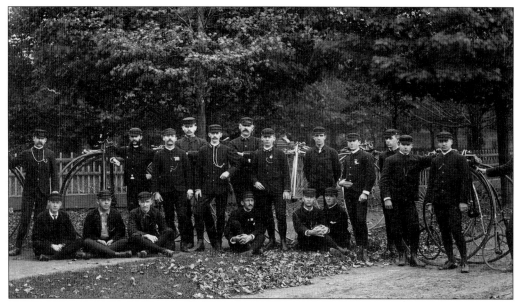

SCRANTON BICYCLE CLUB. Founded in 1881, the Scranton Bicycle Club followed the national bicycle craze. By 1889, the new clubhouse had opened at 545 North Washington Avenue. This c. 1890 photograph, taken in front of the Archbald Home, at the corner of Monroe Avenue and Ridge Row, includes D. R. Stratton, Barney Connolly, Fred Hand, William Connell Sr., Charles Mattes, George Sanderson, John Page, Harry Simpson, John Roe, Jacob Schlager, Theodore Bauman, and several unidentified persons.

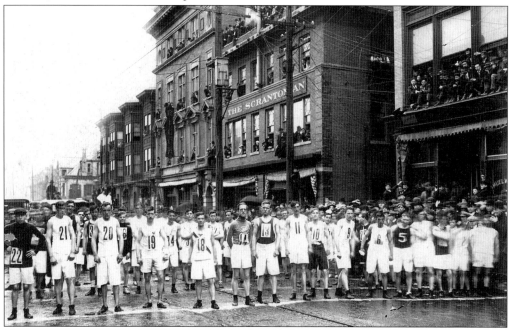

MARATHON ALONG SPRUCE STREET. In this Horgan photograph of the 1909 marathon, the businesses shown are, at 221 Spruce Street, Samuel Williams Leather; at 217, the *Scrantonian*; and at 213–215, Frank Ricca Contractor and Builder and the Foreign Exchange Banker and Steamship Ticket Agent.

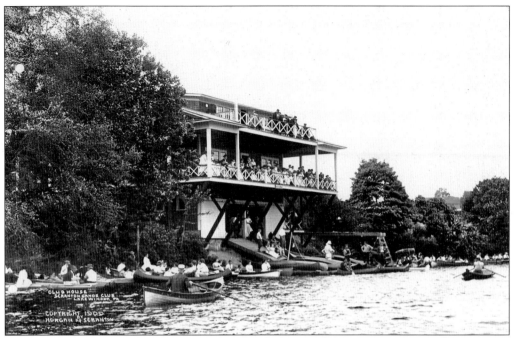

SCRANTON CANOE CLUB. This 1909 photograph depicts the Scranton Canoe Club activities at Lake Winola.

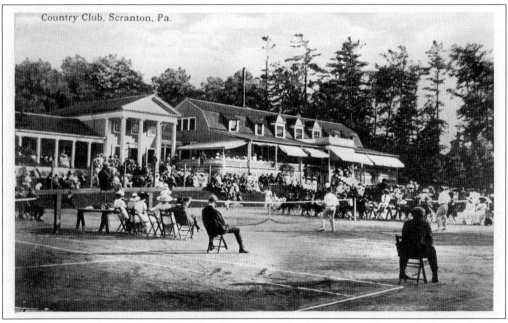

TENNIS AT THE COUNTRY CLUB. The Country Club of Scranton, chartered on October 24, 1896, erected its first clubhouse on North Washington Avenue in Green Ridge. This photograph shows tennis courts, which were added along with an 18-hole golf course, squash courts, and a bowling alley, as part of a 1901 expansion made possible with land purchased from the Pennsylvania Coal Company. Golf and tennis stars appeared at the annual tournaments.

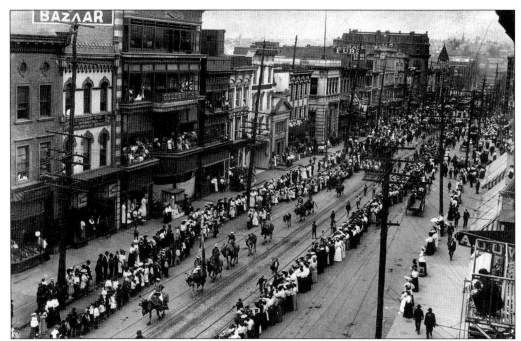

CIRCUS PARADE ALONG LACKAWANNA AVENUE. This circus parade travels along the 400 block of Lackawanna Avenue around 1905.

COAL TRUCK IN PARADE. This parade along Lackawanna Avenue prominently features a Delaware and Hudson coal truck.

REGENT THEATER. In a city famous for its quality entertainment, the Regent was one of three movie theaters on lower Lackawanna Avenue alone. The other two were the Manhattan and the Orpheum. Whenever it showed a World War I movie, the Regent would present a sidewalk exhibit of machine guns, helmets, rifles, and other memorabilia. It closed in 1930, and a United Artists theater now occupies the site.

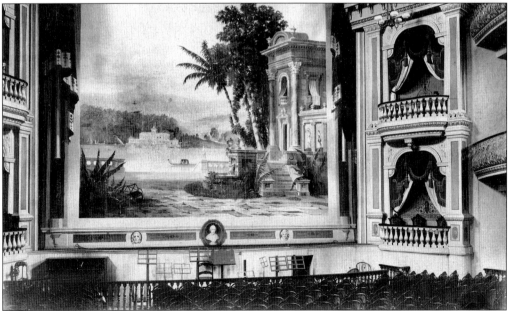

ACADEMY OF MUSIC. Opened in 1877 at 225 Wyoming Avenue under the management of Joseph Walker, this well-equipped theater included dress boxes, an orchestra circle, balcony circle, and gallery and seated 1,500. Offering first-class acting and operatic troupes, it was regarded as one of the finest theaters in the country. It became the Academy Theater, a movie house, in 1920 and was razed in the 1930s. This photograph dates to 1878.

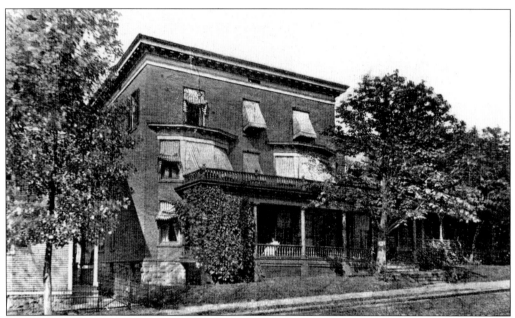

CATHERINE SIMPSON YWCA. The Scranton branch of the YWCA was founded in 1888 in rooms on Linden Street and Washington Avenue, opposite the post office. In 1906, Catherine D. Simpson donated the Hotel Linden as a boardinghouse. The association opened a new home on Jefferson Avenue and Linden Street in 1907 and added the Platt-Woolworth House in the 1920s.

MASONIC TEMPLE AND SCOTTISH RITE CATHEDRAL. Built in the late 1920s as a meeting hall and theater, this landmark structure was designed by renowned architect Raymond Hood, best known for designing Radio City Music Hall. The Romanesque and late–Gothic Revival structure combines elements of the art deco style for which Hood became famous. It was added to the National Register of Historic Places in 1997.

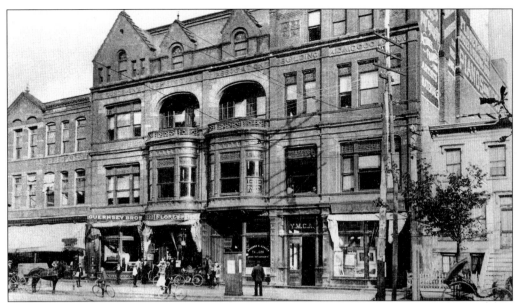

OLD YMCA BUILDING. The YMCA was organized in 1858 to promote spiritual, intellectual, and social conditions. The Scranton chapter first met in rooms above the Neptune Fire Company at Lackawanna and Adams Avenues. It disbanded in 1866 during the Civil War and reorganized in 1868. In 1878, the YMCA relocated to a structure at 220–224 Wyoming Avenue, which burned in 1898. This 1894 photograph shows the old building, along with Florey Sporting Goods and Bicycles and Guernsey Brothers Pianos and Organs.

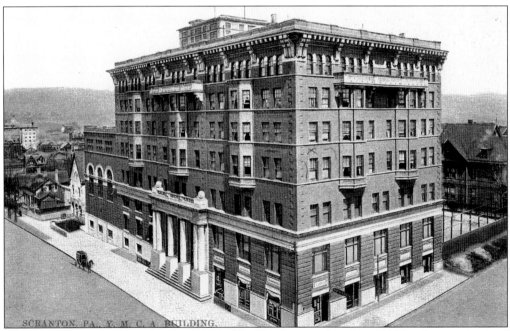

NEW YMCA BUILDING. The fire-damaged building was replaced in 1903 by the one pictured here at North Washington Avenue and Mulberry Street. Originally four stories, the structure gained three floors in 1913 and held a gym, a pool, and 177 rooms. It was demolished in 1974.

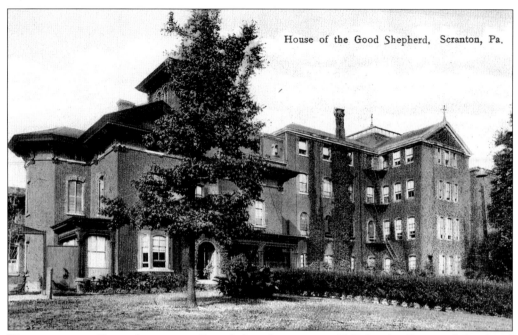

HOUSE OF THE GOOD SHEPHERD. Founded in Scranton in 1889 by the Sisters of the Good Shepherd, this facility was located in a home called Providence. It moved to the Abington Heights in 1919 and now serves adolescents as Lourdsmont.

ST. JOSEPH'S FOUNDLING HOME. The St. Joseph's Society began in 1888 as a women's group and expanded in 1890 under the Servants of the Immaculate Heart of Mary. The St. Joseph's Foundling Home, started on Jackson Street, moved to Adam's Avenue, a site bought from the Pennsylvania Coal Company for $1. The main buildings were completed in 1900, with two wings added in 1909. It took the name St. Joseph's Children's and Maternity Hospital in 1920.

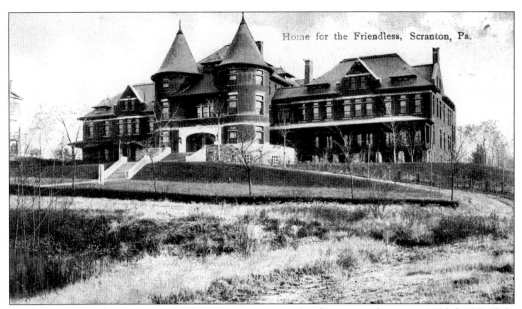

HOME FOR THE FRIENDLESS. William D. Mossman, the first general secretary of the YMCA, appealed to the women of Scranton to care for destitute women and children. In 1871, they rented and furnished a Home for the Friendless on Franklin Avenue and Linden Street. It became the Society of the Home for Friendless Women and Children of Scranton in 1873. The next year, the Lackawanna Iron and Coal Company donated lots on Adams Avenue. Today, the organization operates as Friendship House.

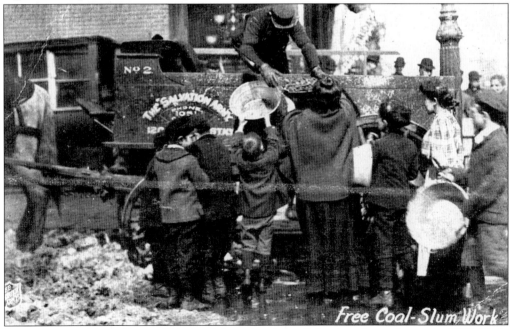

DISTRIBUTING FREE COAL. The local branch of the Salvation Army began in 1885. Early meetings were held in St. David's Hall on the west side. For a time, a branch was located at 1031 Price Street, and in 1929, the group occupied 437 Penn Avenue. Here, the Salvation Army gives free coal to those in need.

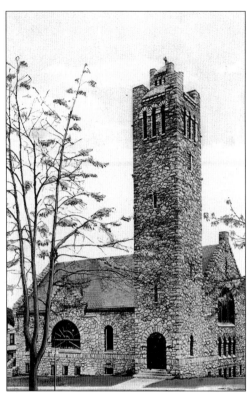

JOHN RAYMOND MEMORIAL UNIVERSALIST CHURCH. Constructed in 1867 as All Souls Universalist Church, this Romanesque building on Madison Avenue and Vine Street was dedicated as the John Raymond Memorial Church in 1902. Today, the structure houses the University of Scranton's art studio.

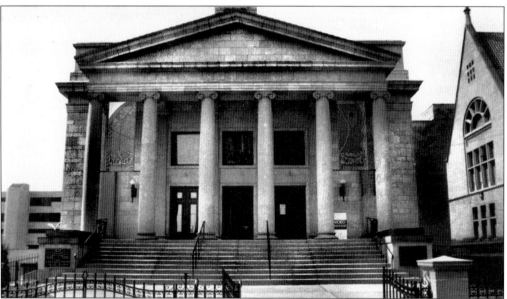

CHRISTIAN SCIENCE BUILDING. The Church of Christ, Scientist, was organized in 1888 at the Jefferson Avenue home of Dr. Hannon, a student of Mary Baker Eddy, and reorganized in 1890. This Classical Revival church was designed by Snyder and Ward and erected at 520 Vine Street in 1914. The congregation included prosperous businessman and prominent citizen William H. Taylor. Purchased as the children's library in 1985, the building was added to the National Register of Historic Places in 1988.

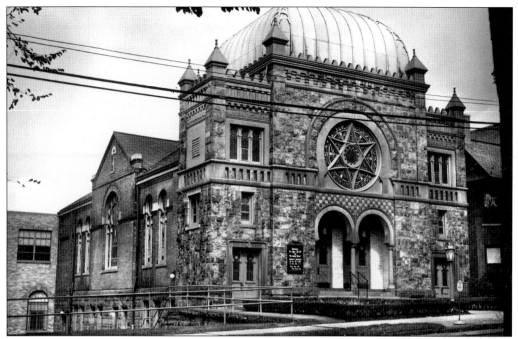

MADISON AVENUE TEMPLE. Jewish families first settled in the area in the early 1800s. In Scranton, Anshe Chesed was chartered in 1862 and first met for worship in Alhambra Hall in the 400 block of Lackawanna Avenue. From there, the group moved to the 100 block of Linden Street and expanded several times before moving to this structure, pictured in 1907. The congregation moved again to its new Temple Israel on Madison Avenue, erected at a cost of $300,000 and dedicated on September 11, 1927.

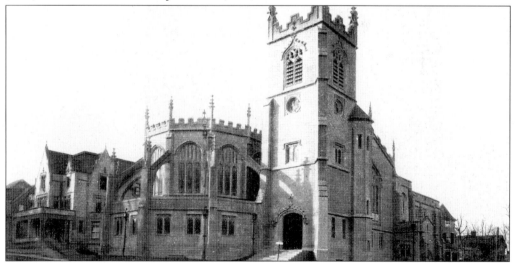

COVENANT PRESBYTERIAN CHURCH. New York City architect L. C. Holden designed this Gothic masterpiece for the First Presbyterian Church congregation, originally housed on Wyoming Avenue. Contractor Peter Stipp built the new church on the Madison Avenue and Olive Street site formerly owned by the Scranton Gas and Water Company. W. W. Scranton laid the cornerstone in 1903. The congregation merged with Second Presbyterian in 1926 to form the Westminster Presbyterian Church, now Covenant Presbyterian Church.

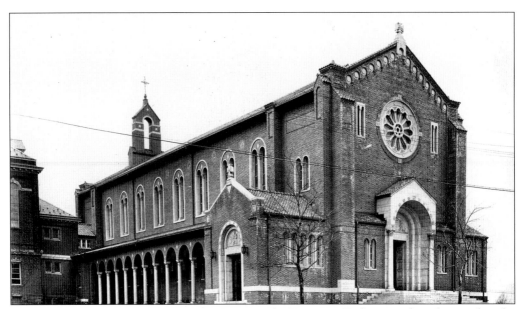

St. Ann's Church and Monastery. In 1902, the Passionist Fathers purchased ground in the Roundwoods section of West Scranton. They privately celebrated annual novenas for St. Ann and, in 1904, laid the cornerstone for a monastery dedicated to her. Mine subsidences threatened the building in 1911 and 1913, but two boulders slid into place, ultimately providing a firm foundation. Novenas became public, attracting 17,000 visitors in 1925. St. Ann's Shrine Church, built in 1929, was elevated to the Basilica of the National Shrine of St. Ann in 1996.

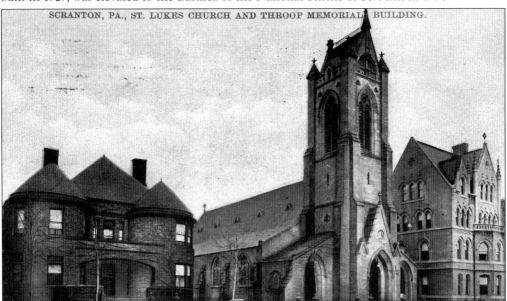

St. Luke's Parsonage, Church, and Church Hall. The parish was incorporated in 1851; in 1852, the congregation commissioned a church from Joel Amsden. His Gothic building, completed in 1853, was located on a Penn Avenue lot donated by the Lackawanna Iron and Coal Company. In 1866, the company provided a lot at 232 Wyoming Avenue. There, the English Gothic–style building pictured here was designed by Richard Upjohn, best known for Trinity Church in New York City.

ELM PARK UNITED METHODIST CHURCH. The Methodist Episcopal Church congregation left its original home in 1891 and met temporarily in a tabernacle on Adams Avenue. Weary and Kramer of Ohio designed the new Romanesque church, built by Conrad Schroeder on the triangular lot bounded by Jefferson and Madison Avenues and Linden Street. Despite two fires, the building was completed in 1893. (Drawing by Rev. Sarah Miller; courtesy of Elm Park Methodist Church.)

PENN AVENUE BAPTIST CHURCH. Organized in 1859 in the Hallstead Home on Franklin Avenue, the congregation met in various locations until a gift of land from the Lackawanna Iron and Coal Company and donations from the Delaware, Lackawanna and Western Railroad and Dickson Manufacturing resulted in a new structure in the early 1870s. This photograph shows the church as it looked in 1909. The building was replaced by a small park and, later, the IBM Building.

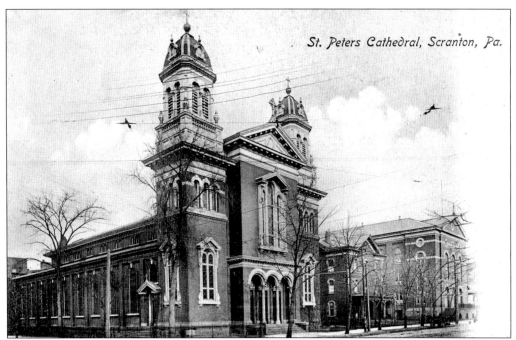

St. Peter's Cathedral. Originally the Church of St. Vincent de Paul, this Romanesque building was designed by Joel Amsden and Lewis Hancock. The cornerstone was laid in 1865, and the building was finished at a cost of $70,000 in 1867. Pope Pius IX created the Diocese of Scranton in 1883, and the church was consecrated as St. Peter's Cathedral on September 18, 1884. It was added to the National Register of Historic Places in 1976.

St. Thomas College. Bishop O'Hara founded this college in 1888 to educate young men for a rapidly changing world. The first class of 62 started on September 8, 1892, with a yearly tuition of $40. Rev. John J. Mangan served as the first president, and the college was staffed by young priests of the diocese. In 1899, the Christian Brothers assumed control, and in 1938, the Jesuits took over, changing the name to the University of Scranton.

MOUNT ST. MARY'S. This girl's school opened on September, 8, 1902, headed by Mother Superior M. Cyril Conway, IHM, and guided by Bishop of Scranton Right Rev. Michael J. Hoban. Mother Cyril chose the term "seminary" over the term "academy" because academy suggested a finishing school for ladies, and seminary was associated with high schools for college-bound men.

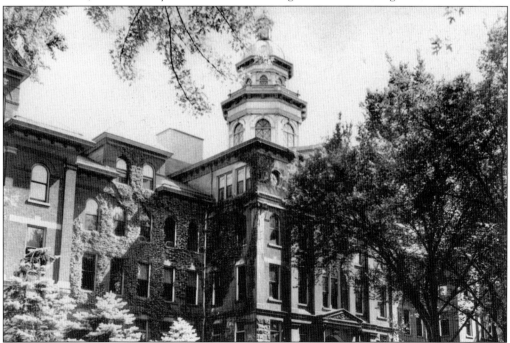

MARYWOOD COLLEGE. Opened in 1915 by the Sisters of the Immaculate Heart of Mary, this was the first Catholic college for women in Pennsylvania. Programs offered in the arts and sciences included education, library science, social work, and nursing.

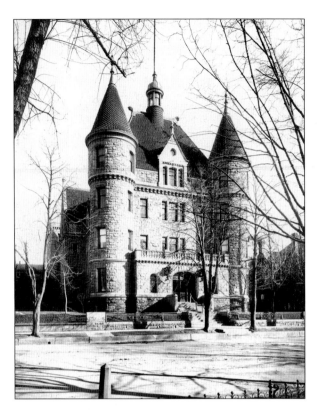

INTERNATIONAL CORRESPONDENCE SCHOOL. Started in response to the need for miners' education, the study-by-mail program made education possible to anyone. In 1894, the International Correspondence School occupied 25 offices in the Coal Exchange Building, employed 55 instructors, and spent $10,000 a year in postage. It then acquired the Finch Building, shown here, at 424 Wyoming Avenue. Designed by W. Scott Collins and built in 1898–1899, this beautiful structure was added to the National Register of Historic Places in 1976.

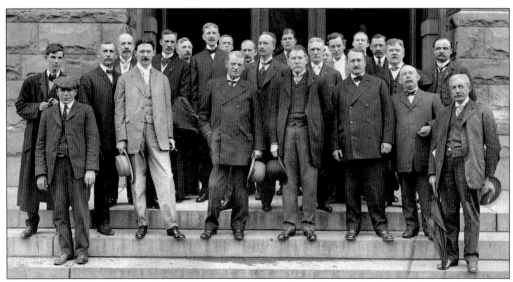

CELEBRATION AT THE INTERNATIONAL CORRESPONDENCE SCHOOL. Shown in this May 7, 1908, photograph, taken at the International Correspondence School, are J. W. Howarth, T. F. Penman, E. H. Davis, Colonel Watres, George Watkins, E. J. Lynett, M. W. Lowry, and S. F. Weyburn.

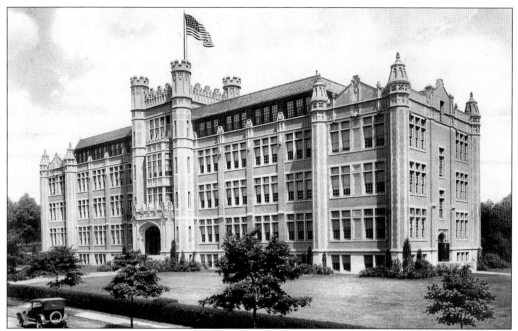

WOMEN'S DOMESTIC INSTITUTE. Originally the administration building of the International Correspondence School, this collegiate Gothic-style, five-story building of cream buff brick, Indiana limestone, and green roof tile was built in 1921 on Wyoming Avenue. The correspondence school grew to include the International Textbook Company, Latin American Schools, and International Educational Publishing Company. The building now houses the Scranton Preparatory School.

INTERNATIONAL CORRESPONDENCE SCHOOL PRINTERY. The rapid growth of the International Correspondence School resulted in the need for this new building—catty-corner from its Wyoming Avenue location—to house its printery. Later, the school brought Haddon Craftsman into the building. The structure was eventually acquired by the Scranton Preparatory School and torn down.

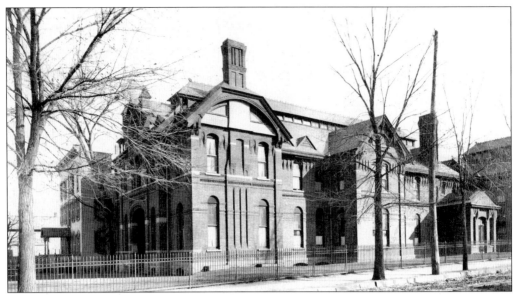

LACKAWANNA HOSPITAL. Founded in 1871 by Dr. Benjamin Throop, a surgeon for the coal companies, the hospital was located in a church building on Penn Avenue, between Lackawanna and Spruce, until a new facility was erected at Franklin Avenue and Mulberry Street. The hospital acquired a special charter and funding from the General Assembly. In 1905, a new building was constructed, and in 1924, its name was changed to the Scranton State Hospital.

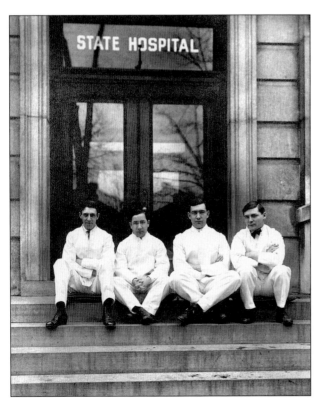

STATE HOSPITAL DOCTORS. Identified here, in this c. 1910 photograph, are Drs. Silverstein, Kingsbury, and. James D. Lewis.

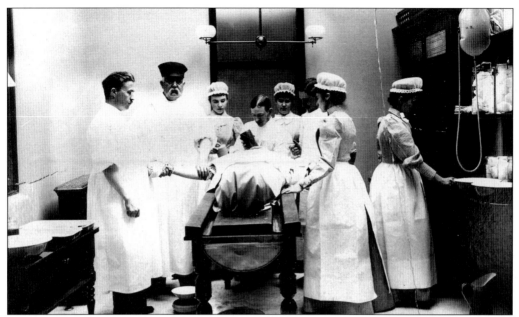

FIRST OPERATION AT MOSES TAYLOR HOSPITAL. In 1882, a gift of hospital funds was made for employees of the Delaware, Lackawanna and Western Railroad and the Lackawanna Iron and Coal Company, with Moses Taylor a shareholder. The hospital opened on October 1, 1892. This photograph, taken in that month, shows Dr. N. Y. Leet, surgeon; Dr. Daniel A. Capwell, assistant; and Dr. A. W. Smith, anesthetist.

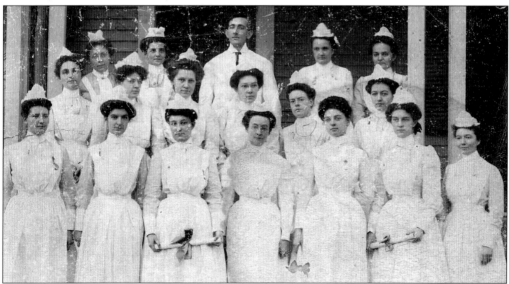

HAHNEMANN HOSPITAL NURSING SCHOOL. Located at Mulberry Street and Colfax Avenue, the 51-bed Hahnemann Hospital also operated a nursing school. The graduating classes from 1903 through 1905 are gathered here. Pictured are the following, from left to right: (first row) Violet Danvers, Bernice Conger, Grace Goodrich, superintendent Grace Smith, Pearl Mollineaux, Elizabeth Robinson, and Elizabeth Wolfe; (second row) Victoria Watkins, Glendora Thomas, Jane Eschenbach, Lula Kester, Harriet Rawson, and Mary Michaels; (third row) Mary Travis, Jean Donaldson, Dr. Hamilton, Ella Avery, and Miss Lane.

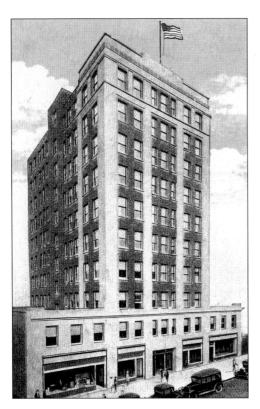

MEDICAL ARTS BUILDING. The Scranton Medical Arts Building opened on April 1, 1929.

PENNSYLVANIA ORAL SCHOOL FOR THE DEAF. Jacob M. Koehler, himself hearing impaired, returned from Gallaudet College determined to teach deaf children through sign language. His first class of six met in the Baptist church at Adams Avenue and Mulberry Street. His efforts to convince prominent citizens of the need for such education resulted in the school pictured here, which opened in 1894 on 10 acres along North Washington Avenue and Electric Street.

OUTING AT WALDORF PARK. The Scheller Social Club conducted a welcome to service members at Waldorf Park on July 25, 1919.

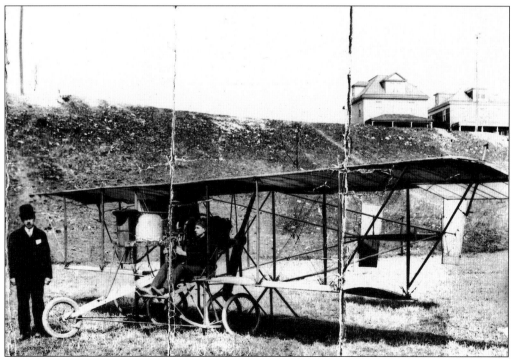

EARLY FLIGHT. In this *c.* 1911 image, Scranton's Albert Boshek is at the controls of an early plane, accompanied by Osbert E. Williams, the plane's builder.

ACKNOWLEDGMENTS

The authors owe a debt of gratitude to the Lackawanna Historical Society, its director Mary Ann Moran, assistant director Mary Ann Gavern, and receptionist Marian Yevics, for their patience, knowledge, and generosity, and to Arnine Cumsky Weiss for forging the path.

Cheryl A. Kashuba extends further thanks to Jack Finnerty, director of the Albright Memorial Library, and to Jack Hiddlestone.

Darlene Miller-Lanning, the recipient of a 2005 Pennsylvania Council on the Arts Commentary: Perspectives on the Arts Project Award for Individuals, administered by the Pennsylvania Humanities Council, thanks these agencies for their support.

Alan Sweeney thanks Ella Rayburn, curator of the Steamtown National Historic Site.

BIBLIOGRAPHY

Beck, John. *Never Before in History: The Story of Scranton*. Northridge, CA: Windsor, 1986.
Freeman, Aileen Sallom and Jack McDonough. *Lackawanna County: An Illustrated History*. Montgomery, Alabama: Community Communications, 2000.
Henwood, James N. J. and John G. Muncie. *Laurel Line: An Anthracite Region Railway*. Glendale, CA: Interurban Press, 1986.
Hiddlestone, Jack. *Scranton Luna Park*. Old Forge, PA: Penn Creative Litho, 1991.
Hitchcock, Col. Frederick L. *History of Scranton and Its People*. Vol. 1 and 2. New York: Lewis Historical Publishing, 1914. Reprinted by the Higginson Book Company, Salem, MA.
Murphy, Thomas. *Jubilee History of Lackawanna County Pennsylvania*. Topeka, KS and Indianapolis, IN: Historical Publishing, 1928. Reprinted by the Higginson Book Company, Salem, MA.
Reilly, Frank T. *Central Railroad Company of New Jersey: Its History and Employees*. Williamsport, PA: Reed Hann Litho Company, 2004.
Scranton City Directories 1861–1930.
Shaughnessy, Jim. *Delaware & Hudson*. Berkeley, CA: Howell-North Books, 1967.
Sutherland, J. H. *The City of Scranton and Vicinity and Their Resources*. Scranton, PA: Scranton Tribune Publishing, 1894.
Taber, Thomas Townsend. *The Delaware, Lackawanna and Western Railroad in the Twentieth Century, 1899–1960*. Vol. 1–3. Williamsport, PA: Lycoming Printing Company, 1980.